TO
PAINT
A
PORTRAIT

QUADRILLE

CONTENTS

TAI SHAN SCHIERENBERG'S INTRODUCTION

We live in an age where we are bombarded with images not only from our immediate vicinity but from around the globe, even from space. These images are incessantly updated and new images added 24 hours a day every day of the year. If we feel that the images we are being fed automatically from news sources, advertising hoardings and notifications from our Instagram and Facebook feeds aren't enough, we can always access more, even videos and movies. Wars, famines and disasters are just a click away, as are talking cats, photos of food, celebrities and selfies. But what we are most interested in is, of course, other people and their stories. Just flicking through today's paper, I can see pictures of murderers, victims, a princess, actors, football stars and more and more of the same, and every image is a portrait, even the advertising. We devour portraiture without noticing it, and anybody with the inclination and an Internet connection now has the freedom to add to this great flood of human images.

Now imagine you are sitting in Ghent cathedral in the 1440s. It is Easter, so the magnificent altarpiece painted by the Van Eyck brothers is open. It is almost five metres wide and more than three meters tall. It is crammed with highly realistic images of saints and angels and the holiest of the holy. As a simple burgher, you have spent most of your life in the town you were born in. Maybe work or pleasure takes you outside of the city walls where you can contemplate nature, and perhaps you surround yourself with some simple rustic decorations at home, but otherwise you are not exposed to much in the way of imagery, so you are absolutely overwhelmed by the visual feast in front of you. You have never seen anything like this – it is miraculous. On the two outermost edges

of the open wings stand two glum characters: an unkempt Adam and a pot-bellied Eve. They are so real in ways you cannot describe that you feel a kind of kinship; through the immaculate rendering of the portraits of these, our flawed ancestors, the idea of original sin is not just a concept anymore but something very palpable.

What enthralled our medieval ancestors, and continues to preoccupy us, is, I think, a sense of Self that we gain through observing others and the images of others. Our identities and our place in the social hierarchy are made real by our human interactions and are constantly calibrated and reinforced, not only by the people we encounter in our lives but also by the images of people we worship, respect, fear and despise. What we react to in these people is not only the face but also the story behind it. From earliest childhood, we learn to read the stories behind the micro expressions and mini gestures in the body language of others, leading to that old canard that states that 93 per cent of communication is non verbal. Of course, a lot of our reading is coloured by social mores and individual experiences, a lot of what we surmise is fallacious and sometimes all we are doing is rearranging our prejudices. Portraiture, in whatever form, gives us licence to stare and imagine. I will never meet the Queen, but a painting of her gives me the opportunity to look and work out what kind of person she is, and whether my republican tendencies are valid. I certainly wouldn't like to meet a murderer, but it is fascinating to see a photograph of one, just to be able to nod and say that I could have told you he was a wrong'un. Recently, I read Hilary Mantel's vivid account of Thomas Cromwell's life at the court of Henry VIII. I was so gripped that I hurried to the National Portrait Gallery to find an image of what he looked like because I just had to see the face of this Machiavellian schemer whose face never gave him away. The great Oscar Wilde novel *The Picture of Dorian Gray* is so successful because we believe the premise of the novel to be true: our bodies and our faces tell the story of our moral state and who we truly are, whether we want them to or not.

To investigate the human condition through making portraits is as of much concern to artists nowadays as it was thousands of years ago. The motives might be different; painting a portrait of a manipulative pope (Velazquez) or photographing a strange child in Central Park (D. Arbus) might seem very different undertakings, but they both involve empathy, an innate understanding of the character of the subject and being attuned to the visual language of the day, knowing how to play with it or against it to make a meaningful and engaging image that says something new. The world changes and looks different, but humans and their concerns remain essentially the same and they have been subject matter for thousands of years. Some artists enjoy being part

of this great tradition, learning from the past and engaging with it in updated ways; others find it burdensome and use new media in an attempt to free themselves. Photography was the biggest game-changer, of course, altering the way the world appeared to everybody, and many figurative artists were forced to rethink what they were doing and give it a purpose beyond verisimilitude. Remarkably little changed, though, except the advent of photorealism as a new branch of realist painting. I don't think there is that much difference between the works of Sargent and Alex Katz; both picture the rich in an elegant way and are a comment on class, purposely or not. Or take the abstraction of a Rembrandt close up and the whorls of colour that make up Chuck Close's huge heads: both have a preoccupation with perception and the language of painting. One could argue that Ruben's paintings of large women spilling out of his canvasses have been updated with a nod to feminism and women's self-image by Jenny Saville, but I'm sure when it came to the actual painting of these flesh masses both artist enjoyed themselves in very similar ways.

Portraits have commonly been made for the commemoration of the great and the good and the departed. The earliest paintings of faces we would recognise as portraits are the mummy paintings made in Fayum in Egypt around the first century BC These were commissioned by high-ranking families to commemorate the recently departed and were attached to their mummified bodies. They were painted in encaustic with a very limited palette of a few earth colours but are so naturalistic and 'present', especially as they typically look directly at the viewer, that it is hard to believe that they were painted after the death of the subject and not from observation of the living person. Until fairly recently, of course, it was only higher-ranking individuals in society who were able to use portraiture as propaganda and subsequently as memorials to posterity. Over the course of about five centuries, the Romans developed the individualised portrait bust from idealised sculpted heads, with their echoes of Greek deities perfect for their intended propaganda purposes, to a level of specificity and unvarnished realism that is so precise that in some cases certain clinical symptoms can be recognised from the carved marble a millennium and a half later. Throughout the Middle Ages, with the growth of the Church, figuration became more non-specific. With the exception of the odd donor portrait in the corner of an altarpiece, the figures depicting scenes from the Bible were generalised, painted from shared templates or invented. With the Renaissance came the reinvention and flowering of a portrait tradition that flowed uninterrupted to the present day, artists continually learning from their antecedents, evolving and incorporating styles from different countries and cultures. The Reformation and the rise of Protestantism in Europe also gave portrait-making a fillip as the Church gave way to the aristocracy and wealthy as the main patrons of the arts, thus opening the way for other genres

apart from religiously themed art to flourish. Our obsession with portraiture in Britain began with monarchs 'importing' portrait artists such as Hans Holbein the Younger and Van Dyck, before home-grown talent such as Joshua Reynolds and Thomas Lawrence brought the British portrait to its apotheosis centuries later. Less than fifty years after Reynolds's death, photography arrived and shifted the whole emphasis of what painted portraiture was about, democratising both the commissioning and making of portraits. Portraits were used to commemorate the dead in the necropoli of Egypt in the same way as small photos are used in Italian graveyards today. Roman senators used them for propaganda purposes as assiduously as any politician these days relies on his makeup team and embedded journalists. From showing one's piety and closeness to God in the pictorial record of one's patronage on an expensive altarpiece in the Middle Ages to contemporary society pages brimming with the shiny rich at charity dos, these images are made both to commemorate the dead and to affirm the existence of the great and the good. They are made to be looked at, and we do so avariciously.

Painting portraits is an odd activity, if one thinks about it. We are social animals and enjoy observing each other, but which other activity gives one the licence to stare at another human being intensely without starting a fight? Well actually, in my own experience and that of my peers, arguments, tantrums and tears do occur quite frequently during portrait sittings. For the artist, it can be difficult when the sitter refuses to pose properly – I once had someone open up a newspaper in front of his face and be quite prickly when I suggested that being able to see him might be necessary for the job! For the sitter, the sheer unrelenting boredom of sitting can come as a bit of a shock, as can the resultant image. It can also be exasperating for a sitter who has posed obediently for hours or days should the artist then decide to start afresh and scrape down all his previous work. (The assertion that all that hard-won information is still in the artist's mind usually doesn't cut much ice, unsurprisingly!) Sometimes the strange intimacy suggests a therapeutic environment, and certainly a lot of psychological baggage gets aired on occasion, which can inform the picture in an interesting way, of course. At other times, a sitter, a captain of industry most typically, feeling that the power balance is tilted in the artist's favour and worrying that the portrait might reveal his vulnerable side, starts to show off. It is therefore not surprising that a lot of figurative artists prefer to use friends or family members to paint from. Of course, this can go awry, too, if the great portraitist Singer Sargent is to be believed when he said, 'every time I paint a portrait I lose a friend'! Self-portraiture is the safest way to get around the difficulties of accommodating another person in the creative process, but of course, with the advent of photography, a lot of these problems have been alleviated anyway, though arguably sometimes to the detriment of the art.

A distinction should be made between commissioned portraits and painting from a paid model or willing friend because the situations are very different. When painting a commission, artistic licence can be severely compromised by feeling the need to get a perfect likeness or even to flatter. Of course, the bigger the reputation of the artist, the less this is likely to be the case: Lucien Freud's 2001 portrait of the Queen depicted her with a five-o'clock-shadowed chin, and Picasso, when told that Gertrude Stein looked nothing like the painting he had done of her, responded coolly, 'she will'. But some sensitive artists do feel an overwhelming responsibility for the wellbeing of their sitter, even if it is a friend or a paid model, to the extent that they feel reluctant to reprimand them if they are posing badly, and can't free themselves of the obligation to make a 'nice' picture of them. The artist needs to be fascinated by the sitter on whatever level, to want to spend time navigating the geography of that face with paint, and the sitter has got to sit still and not mind being scrutinised.

What makes a good portrait? I'm regularly asked this when people find out that I paint people, and I've never got a clear answer because it is such a complex issue. That the painting should look like the person seems pretty unarguable until we think of all the portraits throughout art history we love and revere and realise that, in most cases, we have no idea what these people looked like so cannot judge the veracity of the likeness. To assert that we like the portraits because they really capture the person is thus nonsensical. However marvellous we agree Rembrandt's numerous late self-portraits are, I doubt we could pick him out of a crowd of scruffy old men if he were around today, so this idea of likeness is rather more complicated than one might at first think. The slippery terms 'soul' and 'truth' are often used to try to capture the feeling a great portrait has on one, and it is certainly true that when I stand in front of Rembrandt's depiction of the ancient Margaretha de Geer I am overwhelmed by an emotional energy that I also get from the work of more recent painters, such as Alice Neel. These artists have gone beyond the skin and found a deeper likeness, the very essence of the sitter, and they have done this so well that we feel a deep connection. It is, to quote Alan Bennett (who was talking about writing), like discovering '… a thought, a feeling, a way of looking at things – which you had thought special and particular to you. And now, here it is, set down by someone else, a person you have never met, someone even who is long dead. And it is as if a hand has come out and taken yours'. It is as though the pictorial depiction of another's soul has reacquainted us with our own. One would think that photography would be well suited to do this, and indeed, some photographers are able to communicate this very well too, but I find that when I return to look at a photographic portrait again, I react to it in the same way I did on the first encounter, whereas, in my experience, the painted portrait lends itself to myriad interpretations. As the painter looks up from her

palette or from the canvas where she has just made the latest mark, she sees the sitter anew each time; the painted portrait is an accumulation of hundreds or more fresh encounters between sitter and painter in contrast to the ⅛ second or so exposure of one photograph.

In the summers of 2013 and 2014, Sky Arts ran two portrait competitions with heats taking place all over Britain and Ireland. The curator Kathleen Soriano, Kate Bryan the gallerist and myself were invited to act as judges. Each year we selected our competitors from more than 1800 artists who entered with self-portraits that we viewed digitally. In all, 132 artists took part, painting famous sitters as diverse as Sir Ian McKellen, Juliette Stevenson, Melvin Bragg, Richard Dawkins, John Hannah and Alison Steadman. The generosity of the artists and their courage in producing a fascinating selection of portraits in only four hours under the eyes of the public and cameras made for an extremely engaging programme. Nick Lord, the winner of the 2013 competition, received a commission to paint a portrait of the double Booker Prize-winning author Hilary Mantel for the British Library as his prize. The following year, our winner, Christian Hook, was commissioned to paint a picture of the actor Alan Cumming for the permanent collection of the National Portrait Gallery of Scotland. In this book, we have asked these two artists and ten of their fellow competitors to share their working practices and their thoughts on portraiture with us as they show us how they paint a portrait in a day.

EQUIPMENT

You can, of course, make a portrait with no more in the way of materials than a pencil and a sketchbook or a stick of charcoal and a sheet of newspaper. However, if you want to paint – we're focusing here on watercolours, acrylics and oils – there are certain materials that you will need as basics, as well as others you might want to consider. It's not necessary to start off with everything listed here, nor to buy the most expensive brands, though good-quality paints have more intense colours and are less likely to fade.

Drawing materials

Most of the artists featured in this book used drawing materials – pencil, crayon, charcoal or oil pastel – either to warm up before painting or as a basis for their portrait. Experiment with the following to help you improve your drawing skills and gain confidence.

Pencils Available in different grades from 6H (the hardest) to 8B (very soft), pencils can be sharpened or used blunt and are easy to erase.

Graphite sticks Like pencils but without the outer casing, graphite sticks are chunkier – and can be used on their edges for broader marks – but also messier.

Charcoal sticks and pencils Available in both compressed and 'willow' form, charcoal is great for encouraging bold marks and loosening up. It's very soft, easy to blend and good for creating a mid-tone surface. Charcoal pencils are less messy but any charcoal drawing will need to be sprayed with fixative. (See also Things to try: Charcoal tonal sketch, page 17.)

Conté crayons Square-sectioned sticks in black, white and earth colours, conté crayons can be sharpened, broken and used lengthwise. They are bolder than pencils but less easy to erase.

Coloured pencils Like all coloured media, coloured pencils are made from pigment (the colour) held together with a binder. Depending on the amount of pigment and quality of the binder, coloured pencils may be soft or hard, chalky or more waxy, translucent or more opaque. Water-soluble ones can be used wet to spread colour like watercolour paint.

Things to try:
QUICK CHARCOAL SKETCHES

Here are a few quick drawing exercises to get you loosened up. You'll need just a stick of charcoal, some sheets of A4 paper and a friend to pose for you (or an object to draw).

• *Draw without taking your pencil from the page: it'll help you focus on how the different parts of the object you're drawing are connected.*

• *Draw a series of sketches in between 1 and 5 minutes: it'll help you focus on lines.*

• *Draw without looking at the page: it'll help you focus on hand–eye coordination.*

Dry and wax pastels Made from powdered pigment mixed with wax, pastels and pastel pencils are available in a wide range of colours and are easy to blend. You'll need to finish your drawing with fixative spray.

Oil pastels Unlike dry pastels, oil pastels don't need fixative as the pigment is bound with waxes and oils. Colours can be blended using a turpentine-moistened rag.

Ink pens and markers Felt-tip pens, markers, ballpoint pens or nibbed pens or paintbrush dipped in black or coloured ink can be used to make a variety of marks. Ballpoint pens and fine felt- or fibre-tipped pens can be used for making sketches in the same way as a pencil, though, as they can't be rubbed out, they are less forgiving. Water- or acrylic-based liquid inks can be diluted and used to create a wash as well as for precise opaque lines.

Other drawing materials In addition to the above, you could also try drawing with chalk (white or coloured), wax crayons, white chinagraph (wax pencil)…

Paints

Paints of all sorts vary in quality; the more expensive ones contain more pigment (the base material that contains the colour), which means that colours are more intense and permanent.

Watercolour

Watercolour paints are available both in boxes of blocks of colour, which need to be activated with water, or in liquid form in tubes. The former are a good choice if you're starting out, or if you want to paint outdoors, because even a small box will contain a variety of colours and a palette in the lid. However, you may need to scrub at them to release enough paint for a larger area. Tubes of paint are often more intense in colour and are good if you want to work on a large scale.

Acrylics

Although they are used in a similar way to oil paints, acrylics are quicker drying. They are opaque but can be watered down for more translucency and are available in a wide variety of colours, including fluorescents.

Oils

Oil paints are very versatile but, unlike watercolours and acrylics, they are not water-soluble (though special water-soluble oil paints are available). They are also much slower to dry – it can take months for thick layers to dry fully.

Choosing your painting medium

TYPE OF PAINT	PROS	CONS
Watercolours	Inexpensive: you don't need much to start, just a box of colours, a few brushes and some watercolour paper Quick-drying Water-soluble so easy to clean up	Because of the translucency of the paint, mistakes can be difficult to cover up Most colours are naturally translucent so you will need to use them thickly for rich, deep colour
Acrylics	Quick-drying Can be watered down, like watercolours, for more translucency Water-soluble so easier to clean up than oils Can be used on virtually any surface Available in a wide range of colours, including fluorescents Easy to cover up mistakes	You have to work quickly (unlike watercolours, acrylics are water-soluble only until dry) Can be difficult to blend. Changes can be made only by overpainting as acrylics dry very quickly Brushes must be kept in bath of water during painting and thoroughly cleaned afterwards or they will be ruined
Oils	Versatile: they can be used thickly or thinned with a medium Easy to blend Mistakes can be corrected easily	Slow-drying Not water soluble (with the exception of water-soluble oil paints), so need to be thinned with turpentine, linseed oil or white spirit, and more difficult to clean up You will need to work in a ventilated space with a window open

Brushes

Artists' brushes come in all shapes and sizes. The type you'll need depends on the sort of paint you are using but also on the effect you want to achieve with your brushstrokes. The most common types of tips are rounded, pointed and flat, all of which will produce different marks.

The thicker your paint, the stiffer your brush needs to be. Watercolour brushes are made of soft hair – typically sable, synthetic sable or nylon – which is able to absorb and hold water, preventing drips. Brushes for oils and acrylics need to be coarser – the thick paint would clog up a soft brush. Acrylic brushes are generally made of synthetic fibres, while those for oil are mostly sable or bristle. Those for oils and acrylics also have longer handles.

TIP: START WITH A FEW BRUSHES
It's not worth buying a lot of expensive brushes when you're just beginning. Start with a selection of inexpensive ones: you'll soon discover which sizes and shapes you use most often and can then gradually replace those with better-quality ones.

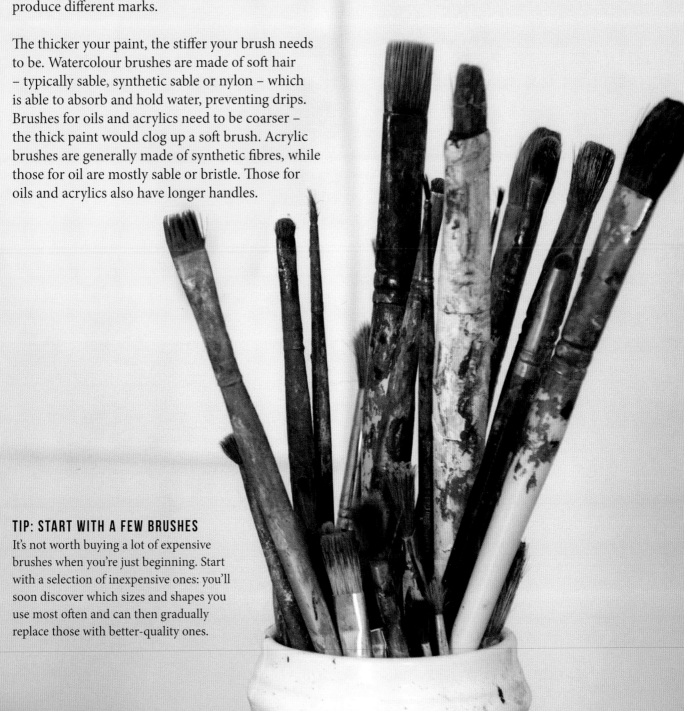

Surfaces

The painting surface (or 'support') you choose will likewise vary according to what sort of paint you're using. Paper is the most common surface for watercolour and can also be used for acrylics (and even oils if heavy enough). Canvas or board is the most usual support for both oils and acrylics.

Paper

As a drawing surface, you can use anything from plain photocopy paper to coloured cartridge paper, a sketchbook or even brown paper or newspaper, but for watercolours, you'll need thicker art paper. Watercolour paper is graded by weight, from 90–300lb, the most popular being 140lb. Paper lighter than 200lb usually needs to be stretched before use to prevent it buckling (see page 22). It also comes in three textures: smooth ('hot-pressed'), medium-rough ('not', i.e. not hot-pressed, or 'cold-pressed') and rough.

Canvas

You can buy canvases of various sizes that have already been pre-stretched and primed and are ready to paint onto. Prepared canvases can be expensive so if you are painting a lot, or if you want to work with unusual sizes or formats, you might prefer to buy canvas by the metre and stretch and prime it yourself. Linen has a finer, smoother weave than canvas but is more expensive.

Board

Board provides a harder surface, which some artists prefer to canvas (it's also useful if you're building up thick layers of paint with a palette knife), but you'll need to prepare and prime it first if you're painting with oils (see Primer, opposite).

Easels and boards

An easel will enable you to view your painting from the same angle and prevent you from stooping (though if you're working in watercolours, you may prefer to work on a flatter surface as watercolour drips so easily). Easels range in type and quality from simple tabletop versions to ones that can be folded away for use outdoors. Make sure you choose one that is fully adjustable.

If you are working on paper, you will also need to have a large, smooth board to tape the support to.

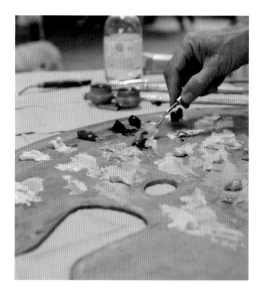

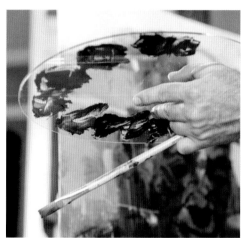

Palettes

The type of palette you use to mix your paint colours before applying them to the painting surface will depend on your chosen medium.

Palettes for watercolours need different compartments to prevent the colours running into each other. Boxes of watercolour paints often include a palette in the lid. Alternatively, you can buy a watercolour palette.

Palettes for acrylics are usually made of glass or white plastic but you can use any non-absorbent surface. The best solution, however, is a 'stay-wet' palette, a shallow tray lined with a damp absorbent tissue layer then a non-absorbent layer on which you mix the paints. This prevents the paints drying out and is easy to clean – you simply throw away the wet tissue and film.

Palettes for oils are generally flat with a thumbhole for holding. They are usually made of wood, which is easy to scrape down. Alternatively, you can buy pads of disposable palettes, which cuts down on cleaning.

Other materials

You may also need the following:

- **Erasers** – for erasing mistakes, mark-making and lifting out. Soft, putty ones can be pulled apart and moulded; small pencil-end ones are good for details.

- **Acetate** – for tracing if you are using a grid (see page 29).

- **Fixatives** – for spraying completed drawings in pastels, charcoal or chalk to prevent smudging. Hairspray can be used as a cheap alternative.

- **Masking tape or gummed paper tape** – for attaching paper to the board.

- **Mediums** – for thinning oil paints (see also page 24).

- **Rags and sponges** – for wiping brushes after washing and for dabbing off excess paint. Kitchen paper is the best solution for watercolours but isn't strong enough for acrylic and oil paints.

- **Primer** – for painting a board to use to paint on with oils. The most usual primer is clear or white gesso.

- **Masking fluid** – for masking off areas of a watercolour painting that you want to keep white.

- **Palette knives and painting knives** – for mixing paints on the palette and applying and working thick layers of acrylic and oil paints.

- **Mirrors and viewing frames** – for getting a fresh, objective look at your work (see page 29).

BASIC TECHNIQUES

Learning how to really see an object and to depict it in a three-dimensional way is a skill that can be developed. It also helps to have a basic understanding of the attributes of different painting mediums and how to use them. There is, of course, no substitute for practise, so you'll find here some ideas for exercises to try to improve your skills, too. We'll look at more techniques in the next section, which focuses on the specific challenges of painting a portrait.

Three-dimensional painting

One of the difficulties in drawing is portraying a three-dimensional object in two dimensions. Part of the problem is that we tend to draw based on our knowledge of an object rather than what we're actually seeing. Because we know that a cup is a separate entity from the table on which it is sitting, or the wall behind it, for example, we tend to draw a line around it to distinguish it. But in reality, not all objects have solid contour lines. It is much more helpful to learn to see objects in terms of their shapes and tonal variations.

Shapes

Learning to focus on areas of dark, mid-tone and light will help you start to see things in terms of a series of shapes rather than simply outlines. Shapes are created not only by things themselves but also by the empty space around and between them, what we call negative space. It's often easier to see negative spaces because we don't make the same assumptions about them (we think we know, for example, what a hand 'ought' to look like). Negative spaces also give us information about the relationships between other shapes.

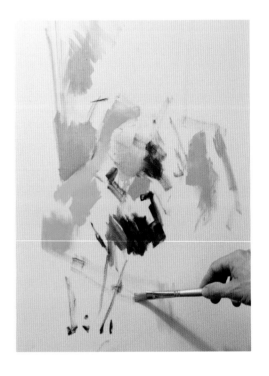

Things to try:
NEGATIVE SPACE FIGURE

Ask a friend to strike a pose for you – you'll be drawing the whole figure and it'll help if legs are slightly apart and arms away from the sides of the body. Focus your attention on the shapes created by the spaces between the arm and the body, the head and the shoulder, the legs, etc. and shade in these areas rather than trying to draw an outline of the body. Try the same exercises with a number of different poses, spending no more than five minutes on each.

Tone

Without shading, it will be difficult to make an object look three-dimensional. If you look at a black-and-white photograph – particularly one with strong contrasts (think of a Hitchcock film still, for example) – you will probably find it easy to see differences in tone (darkness and lightness). But the world we live in is three-dimensional and colourful and accurately judging areas of light and dark in an object is more difficult than you might think. Knowing that shadows are cast in areas blocked out from the light will help you predict where darker areas will appear, but here, again, it is important to focus on what you are actually seeing rather than what you expect to see. Squinting at an object will help: although it will become blurry, you should be able to see contrasts between light and dark areas more clearly. Ask yourself questions about what you see: where are the dark areas? Which areas are highlighted? Where are the mid-tones? Are there areas of high contrast, where the change between light and dark areas is abrupt? Or does one area fade smoothly into another?

Things to try:
CHARCOAL TONAL SKETCH

For this exercise to help you learn to see dark, mid- and light tones in an object, you will need just a stick of charcoal, a sheet of white A4 paper, a putty eraser and a simple object to draw.

- *Using the edge of the charcoal, lightly cover the whole sheet of paper then smudge with your fingers for a smooth even surface.*
- *Lightly draw the outline of the object then squint and look for the dark, light and mid-tone areas. Lightly draw in the shapes of the dark areas, then those of the lightest areas. The remainder will be mid-tone.*
- *Shade in the dark areas, then use an eraser to lift out the light areas.*
- *Once you've differentiated these tonal variations, see if you can refine your drawing by distinguishing between contrast and smooth tonal gradations.*
- *For a variation on this exercise, try drawing without using line at all, simply filling in shapes with shading and lifting out highlights.*
- *You could also use charcoal and white chalk on a mid-tone surface – blue cartridge paper or brown parcel paper, for example.*

Understanding colour

Whatever the medium you decide to use, you will be confronted by a huge – and enticing – range of paint colours. However, even if you have many colours at your disposal (which is likely to be the case if you buy a box of watercolours, for example), it is important to understand the basics of colour pigments and the effects complementary ones have on each other, so that you learn both how to see colours more clearly and how to mix them to achieve the exact shade you're after.

Primary and secondary colours

Red, blue and yellow are called primary colours because they cannot be mixed from any other colours. Secondary colours are made by mixing two of these primary colours together: red + blue = violet, red + yellow = orange, blue + yellow = green. However, confusingly, there is more than one variety of red, blue and yellow and the effects of mixing them can be quite different.

Complementary colours

Complementary colours are those that are opposite each other on the colour wheel: red – green, blue – orange, yellow – violet. Complementary colours neutralize each other, creating subtle neutrals that vary depending on the quantities and temperature (see below) of each colour used.

Colour relationships

No colour stands in isolation and a given colour will look different depending on what it is placed next to. As with tone, colour contrasts can be subtle or striking. A brightly coloured object will look much brighter against a neutral background than if the background is of a similar hue.

Colours are often described in terms of 'temperature': those with red and yellow in them are described as being warm, whereas those with a lot of blue in them are cool. However, there are warmer and cooler versions of each primary colour: ultramarine is warmer than cerulean and lemon yellow is cooler than cadmium yellow, for example.

Mixing colours

A colour will be affected not only by its relationship with those around it but also by the colour of the surface you're painting on and the opacity or translucency of the colour. All paints can be thinned down (with water or a medium depending on the type of paint) to make a colour more translucent.

To lighten or darken a primary colour, the solution isn't always, as you might think, to add white or black. Adding blues and reds will usually make a colour darker, whereas yellow is a lightening colour. To take the brightness of a colour down, try adding a touch of its complementary colour.

TIP: BE BOLD

It's generally easier to tone down a bold colour than to increase its intensity once it has become too muddy.

A STARTER PALETTE

Begin with as few colours as possible and gradually build up if you find you need more later. It's a good idea to have two or three of each of the primaries plus white (if you're using oils or acrylics). The following would be good for a start:

- Reds: cadmium red, crimson
- Yellows: cadmium yellow, lemon yellow, yellow ochre
- Blues: ultramarine, cerulean blue, Prussian blue

Things to try:
MIXING BROWNS AND BLACKS

Practise creating your own browns and blacks by mixing the three primary colours together.
- *For black, start by mixing dark red and dark blue together, then add a touch of lemon yellow.*
- *For brown, mix blue and yellow, then add red a little at a time.*
- *Experiment with different reds, blues and yellows in different quantities and note the results.*

Watercolour basics

Fluid and spontaneous, watercolour is hugely popular and is often seen as the ideal transition from drawing to painting. Watercolour painting has a reputation of being difficult but it's really just a matter of adopting a different approach. Because watercolours dry so quickly, it can be difficult to correct mistakes, so you need to think ahead – and to be bold and decisive!

Things you'll need
- Good-quality watercolour paper
- Soft-bristled brushes: small, medium, large
- Watercolour palette
- Watercolour paints
- Board
- Gummed paper tape
- Kitchen roll
- Pots of clean water
- Small natural sponge
- (Masking fluid)
- (Cotton buds)

Planning ahead
Some watercolourists like to draw onto the surface before painting, others start with the paint straight away. Given that it's not easy to make major corrections to watercolours, drawing first can give you confidence and save you time later. Use a soft pencil, a plastic or soft putty eraser (if you need to correct your drawing) and light touch to avoid damaging the paper. Alternatively, use a water-soluble pencil. With watercolour, you need to think, too, about what areas not to paint: colours are translucent and are generally lightened by adding water rather than white. Some artists use masking fluid (which is rubbed off once the painting is thoroughly dry) to mask small areas they want left clear. Masking fluid can also be used to create some interesting effects.

Things to try:
LAYING A WASH

A wash is an area of colour that covers a larger area than an individual brushstroke could and is a key aspect of watercolour painting.

- *For large areas, mix paint into water in a jar rather than the other way round (but avoid using too much water to start with or you'll waste a lot of paint!)*
- *Tilt your board at an angle to encourage each band of colour to flow into the next so that you get an even surface.*
- *For a flat wash on dry paper, draw your brush smoothly across the paper then repeat with successive bands of colour.*
- *For a flat wash on wet paper, first dampen your paper all over using a dampened natural sponge then lay your paint as above, using either a paint brush or the sponge dipped in the colour.*

TIP: ALLOW FOR FADING
Bear in mind that as watercolours dry the intensity of their colours lightens by about 30 per cent.

Layering

Because watercolour paints are translucent, you need to build up the colour in layers, working from light to dark. Make initial marks and layers in a light thin tones and build up the picture using darker colours when you're sure where to put them, allowing the painting to dry between layers to avoid colours flooding into each other. (You can use a hairdryer to speed up the process.) This method, also known as wet on dry, allows you to create intense colours, built up over several lines, and clear distinct lines.

Working wet into wet

Applying new colours before the previous layer has dried creates a completely different, more 'fluid' effect. You probably won't want to use this technique overall, particularly in a portrait – it's unpredictable and can look too soft and woolly – but you might want to experiment with it for backgrounds, for example.

Lifting out

Soft, diffuse effects or highlights can be created by lifting off paint before it has dried, dabbing or wiping it with a very slightly damp sponge, cotton bud or piece of kitchen paper. Mistakes can be corrected in the same way.

STRETCHING WATERCOLOUR PAPER

All but the thickest paper will need stretching before use to prevent it buckling, particularly if you are going to be laying washes or working wet into wet.

- Soak the sheet of paper for a few minutes in the sink or bath. Carefully lift it out and shake off excess water then place it on your drawing board.
- Cut four strips of gummed paper the length of each side and dampen them by running them across a wet sponge.
- Place a length of gummed tape along one long edge, smoothing it out from the centre and making sure it is attached to the board along its length.
- Stretch the paper down and attach at the other long edge, then fix the two shorter edges in the same way.
- Don't worry if the paper appears to buckle slightly; it will dry flat.

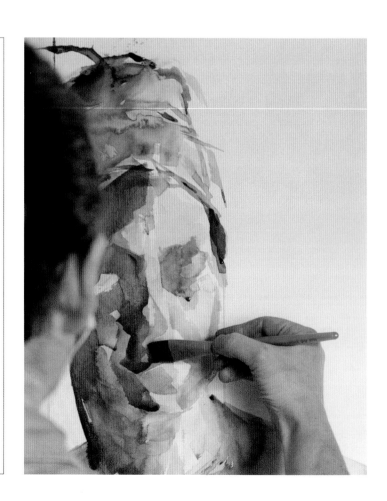

TIP: MIXING OILS AND ACRYLICS

Note that oil paints can be used over acrylics but not the other way round. (Some artists, e.g. Christian Hook, see page 78, create an underpainting with acrylics before switching to oils.)

TIP: CLEANING ACRYLIC AND OIL BRUSHES

Keep acrylic brushes in a jar of clean water while using them and clean them thoroughly when you've finished. If acrylic paint is allowed to dry on the brushes, you'll need to dispose of them! Oil brushes will need to be cleaned in solvent. Avoiding leaving hair and synthetic brushes standing upright in it though or the tips may become damaged.

Acrylic basics

If you're new to painting, acrylics could well be the place to begin. The effects you can achieve are very much the same as with oils (see page 24), but acrylic paints dry much faster. Most of the time that's an advantage – you don't have to wait so long for layers to dry – although it does make blending colours more difficult. Acrylic paints can be used straight from the tube or thinned with water.

Things you'll need
• Board, paper or canvas to paint on
• Selection of acrylic brushes
• Palette
• Acrylic paints
• Freestanding or table-top easel
• Rags and sponges
• Pots of clean water
• (Palette and painting knives)

Blending
Because acrylic paints dry quickly, you'll need to blend colours on the palette rather than on the support. Mix light, mid- and dark tones of each colour you want to use in large enough quantities so that they don't dry out before you've had time to use them, but without being wasteful. You can blend the edges of colours into each other on the canvas, of course, but you'll need to work faster than you would in oils and won't be able to move them around in the same way. It is possible, however, to add a retarding medium to acrylic paints to slow down the drying process.

Correcting mistakes
The easiest way to correct mistakes with acrylics is simply to overpaint. Removing paint is less easy to do than with oils. You can use a knife to do so but you'll need to be careful to avoid inadvertently peeling off colour from surrounding areas.

BRUSHWORK
Both acrylics and oils are thick and creamy when undiluted and so hold the marks of the brush well. Many budding artists forget about brushwork because they're too busy concentrating on composition, colour and other issues, but brushwork is also an important aspect of a painting and can be used to impart movement and energy as well as textural detail. Try experimenting with different sizes and shapes of brushes to see what sort of marks they make.

Oil basics

Used to paint masterpieces for centuries, oil paints are what many people aspire to. The majority of our featured artists have chosen this medium and show, in their very differing styles, how versatile oils can be. Techniques can be similar to using acrylics, but oils take much longer to dry, which sometimes requires you to adopt a different approach.

Things you'll need
- Board or canvas to paint on
- Primer for preparing board (or untreated canvas)
- Selection of oil brushes
- Palette
- Oil paints
- Freestanding or table-top easel
- Pot of solvent for cleaning brushes
- Rags and sponges
- Mediums for thinning paint
- Palette knife
- (Painting knives)

Using mediums

Although they can be used straight from the tube, oil paints can be thinned with linseed oil, turpentine (turps), white spirit or a mixture, or you can buy a low-odour pre-mixed medium. Other mediums change the nature of the paint in other ways: glazing mediums will provide more translucency without thinning it; impasto mediums will make it thicker. Solvent-based mediums tend to speed up the drying process while oil-based ones will slow it down.

'Lean to fat' or 'alla prima'?

Not until the Impressionists did 'alla prima' painting – or blending in new colours before the previous layer has dried (also known as 'wet into wet') – did it become the norm. Prior to that, artists would paint in layers, working from thinner ('lean') paint layers to thicker ('fat') ones. These days, both techniques (which are also known as, respectively, indirect and direct painting) are used.

 If you don't want to wait for paint to dry before adding new colours, you'll need a light touch and to avoid too much overworking or you'll quickly find yourself with a muddy mess. If you work in layers, always start with thin ones, adding details thicker later if you wish. This is not only because thinner layers will dry faster but also to avoid the cracking that can occur when a thin top layer dries before a thicker bottom one.

Removing paint

The easiest way to correct mistakes in oils is to scrape off the wet layer of paint using a palette knife. Scraping off can be used as a technique in its own right as a faint image of the paint layer will remain, enabling you to build up subtle colour effects.

IMPASTO

Both oils and acrylics can be used either straight from the tube or mixed with a thickening medium (necessary for acrylics, which are slightly runnier) and built up in thick layers. Both the technique and the medium are known as impasto. You can model the thick paint with a brush, a knife or even with your fingers, creating areas of relief to highlight aspects of the painting.

TIP: DISPOSING OF MEDIUMS

Don't pour solvents down the sink! Dispose of them responsibly by sealing the jar and taking them to a recycling or hazardous waste disposal facility. After washing brushes in solvent, allow to settle then carefully pour off the clear solvent for reuse.

PAINTING PORTRAITS

Painting a portrait presents unique challenges to the artist, not least because a portrait should not simply look like a person but – ideally, at any rate – should look like the person you've painted! But while achieving a likeness is a worthy goal, a portrait also needs to be interesting as a painting, so you'll need to give some thought to its composition – size, format, pose and placement of the model – too. Finally, while there are certainly guidelines you can bear in mind when painting figures and faces, nothing beats measuring, learning to observe and trust what you see and, of course, practice!

Your workspace

You may not have the luxury of a big studio, but if possible, choose somewhere with lots of natural light. Particularly if you're painting with oils, and your portrait is going to take more than a day, it's good to have a table or space that you don't need to clear away between sessions. Ideally, ambient lighting should be provided by overhead natural-light fluorescent bulbs.

Position the easel so that it is at a comfortable height for you to use whether sitting or standing (whichever you prefer). You should be able to see both your subject and your canvas without having to crane your neck or twist your body. You will also need to ensure that your materials are within easy reach.

Choosing a subject

Most portraitists work from life, even if they also use photographs for reference and close-up details. If you're just starting out painting portraits, you may have to rely on whichever friend or family member you can cajole into sitting for you! It's not always easier to paint someone you know well: you may find it harder to be objective and be swayed by the desire to please them with a flattering portrait. On the other hand, you'll probably find it easier, both to see if you've got a likeness and to ask them to keep still!

Children and people with round faces can be more difficult to depict than older subjects whose faces have more contours, shadows and wrinkles. However, don't fall into the trap of over-emphasizing lines and shadows: not only will your sitter probably not thank you but, more importantly, your portrait will look fussy.

Things to try:
FINDING A SUBJECT

There are lots of alternatives to finding a friend to model for you. You could, for example:
- *Enrol in a life-drawing class*
- *Visit a museum and sketch a statue*
- *Draw from a photograph (either freehand or using a grid, see page 29)*
- *Make quick sketches of people around you, e.g. in the park, on the train or in a café*
- *Try a self-portrait, working from your own face in the mirror*

Composition

The subject of your portrait is only one of the choices you'll have to make about the composition of your painting as a whole. Here are some other issues you'll need to consider.

Size and format

Resist the temptation to start small: trying to add detail to a small painting is fiddly and more difficult than painting bigger. If you're worried about the challenge, paint large but less – just the head and shoulders rather than a whole figure, for example.

The format of your painting will be determined by the pose of your model and how much background you decide to show.

Placing your subject

How do you want to portray your subject? Face only, head and shoulders or full figure? Seated or standing? What is to be the focal point?

A three-quarters stance is generally more interesting than a straight-on one, which can look stiff and unnatural. Avoiding placing the head in the very centre of the space for the same reason. Indeed, you could even crop out some of the figure, if you wish, for a more interesting composition.

The same applies to backgrounds. In portraits showing only the head and shoulders, the background is often left simple to focus attention on the face, but if you're painting the whole figure, you'll need to provide some sort of context.

Lighting

Make use of natural light wherever you can but avoid direct sunlight: you don't want your subject squinting. As the sun will move and fade throughout the day, you may also need to set up lighting to keep shadows consistent. The direction of the lighting can have a dramatic affect on the style of a portrait. Always direct lighting from only one area: competing directional lights will create forms that are flat. Lighting from overhead is generally unflattering, but you could choose to direct light on the side of the face either nearest to or furthest away from the viewer.

GUIDELINES TO FACIAL PROPORTIONS

The following are rough general guidelines only for a face seen looking straight ahead:

- A face can be divided into three equal parts: hairline to eyebrows, eyebrows to base of the nose, base of the nose to the chin
- The tear ducts are midpoint between the crown and the chin
- The mouth is usually the same width as the distance between the pupils
- The space between the eyes is usually the same as the width of one eye
- Seen from the side, the distance between the back of the head and the tip of the nose is generally greater than that from the top of the crown to the base of the head

Proportions and measuring

Getting the proportions of a face right is crucial in gaining a likeness. There are some general guidelines that are worth bearing in mind to help you stay on track (see below), however all faces vary and there is no substitute for taking accurate measurements.

Taking measurements

While understanding both general principles of proportion and rules of perspective can be helpful, they can also be confusing. It is crucial to question everything and not to make assumptions about what you're seeing. Try to establish from the outset some key markers, for example the widest point on the face and the midpoint between the top of the head and the chin.

The best way to ensure a likeness is to take measurements constantly. Hold a pencil at that arm's length to measure the size of facial features and the relationships between them. (How many times does the smaller distance fit into the bigger distance?) You'll find it easiest to keep the pencil steady while moving it if you hold if from the top rather than underneath. You can also use the pencil to help you discern the correct angle of diagonal lines.

Gaining a fresh perspective

Several of our featured artists rely on mirrors or viewing frames to help them gain a fresh perspective of their work. You can create the latter by cutting a window the same format as your portrait into a piece of card. Aine Divine (see pages 44-55) even turns her canvas on its side, or upside down, and while this is partly to control the direction of drips, it also has the same effect of making her see things from a different angle.

USING A GRID

If you are working from a photograph or sketch, you might want to use a grid, like Bill Bone (see pages 98-107), to ensure accuracy.

- Draw a grid of squares over the printed photograph – or add one digitally if you're working from a computer screen – then a larger one onto your support. You'll need to work out the proportionate sizes of the squares mathematically depending on how large your portrait is to be and it's a good idea to number them to avoid errors when transferring the information.
- Redraw the image, square by square, taking care to see at what point lines of the image intersect the grid squares.
- If you don't want the grid lines to be visible in the finished painting, use a putty rubber to erase them once you've transferred the image.

TIP: WORKING WITH A PHOTO

Many artists work at least partially from photographs. If you have a digital photo, you can blow up areas on a computer screen or tablet to help you get details right.

THE PORTRAITS

NICK LORD

PAINTS IN ACRYLIC

Nick completed his Fine Art course at Kingston University, where he gained a
First, in 2011. He was painting and exhibiting part time, as well as working in
his father's business, when he entered the 2013 Sky Arts portrait competition.
The self-portrait he submitted impressed the judges with the freshness of its
composition, feeling for light and unusual painting technique. After a precariously
slow start, he went on to win his heat in Cardiff with a boldly painted head of
Gavin Henson. A trip to Paris with his fellow semi-finalists to paint Sophie Dahl
followed, and he eventually proceeded on to the final, which he won with a deeply
moving and ambitiously composed portrait of Lance Sergeant Johnson Beharry.
As the winner of the competition, he was commissioned to make a painting of
the double Booker Prize-winning author Hilary Mantel for the British Library.

A Good Portrait

In contemplating what makes a good portrait, Nick often crosses the line
between maker and viewer. He says it has to be intriguing and timeless; it has
to be interesting to paint; and it can ask questions about both the sitter, such as
what they might be thinking, and the painter's decisions, such as the choice of
background. He admits it's often hard to explain why one background might work
better than another. Likeness is important but so, too, is the process of painting
– the way the paint is applied and the effect this produces. Sometimes a painting
might not be anatomically correct but it captures the essence of the sitter, which
is the most important thing. It doesn't have to reflect the way the person sees
him or herself; however, if the portrait is a commission and you have to please
the subject and the people who have requested it, that can be tricky to negotiate.
When working on his own portraits, Nick often starts with an idea about a pose or
composition, but he is open to adjusting the picture if better options appear during
the process. He also appreciates the freedom of going after what he is looking for
in the work rather than having to please someone else.

Influences

Nick's influences range from figurative, landscape and graffiti artists to a
photographer who plays with ideas of celebrity and likeness. The list includes
Manet, Courbet, Schiele, Jenny Saville, Peter Doig, Lucien Freud, Conor
Harrington, Alison Jackson, etc. 'What inspires me is the way the paintings look
and how they make me feel', he says. 'When I look at a painting, I'm looking at
how it's been painted. I want to see the texture and construction of the paint.'

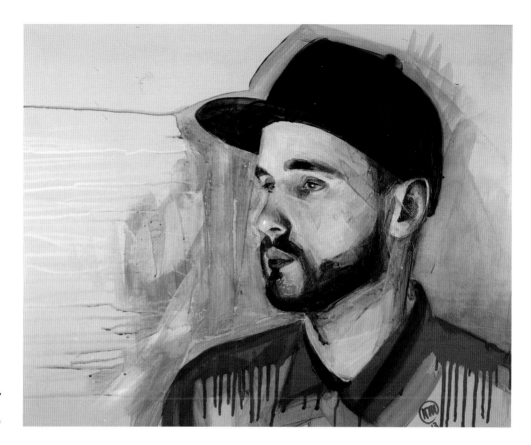

SELF-PORTRAIT
NICK LORD

Style and Technique

His painting style, with its translucency combined with solid lines and drips, is created with an unusual technique he learned at university. He doesn't get on with oils at all, although he wishes he could because it's malleability intrigues him. Instead, he uses acrylic paint, which he mixes with acrylic medium gel. This increases both the body of the paint, creating texture, and its transparency, and speeds up the drying time, which enables him to build up the layers of paint. Liquid copolymer emulsion thins the paint further, creating a more liquid state and increasing the transparency. He also uses it to get the lines. A warm environment and board rather than canvas help speed up the drying process thus enabling repeated layering. The process of layering has occasionally led to him losing the image and likeness and he has had to start again. Alternatively, he will just push on by working into it more and making it even thicker.

Before he started using the copolymer, he used to make a wash by thinning the paint so much with water that it would drip. He liked the effect: it related to spray painting and the dripping one gets from overspraying. He's always been influenced by graffiti art, so it developed from there. Sometimes he uses spray painting for backgrounds, clothing and parts of the body, but never for the face, and usually only on large-format canvasses. As he has developed his technique, these drips and accidents have become more controlled and intentional.

Nick doesn't like working on something for too long and likes to see a painting developing quite quickly. He says he has a love/hate relationship with the canvas and would lose his mind if a painting took him longer than two weeks, let alone two years like it does some artists.

Today's Portrait

Today's sitting takes place in Nick's spacious studio in a warehouse in Cardiff. His sitter is his friend Danny, whom he has chosen because he is young and dapper, with soft features and big dark eyes, which are a powerful focal point. He has never painted him before and this is Danny's first time sitting for a portrait. Nick is in two minds about the need for the sitter to be still but also engaged: you don't want them moving around so much that capturing their likeness becomes impossible, but you also want to get a rapport going that informs the painting. As he knows Danny, this isn't a problem and things stay relaxed and informal throughout the day as Nick works to a constant background soundtrack of hip-hop and DJ mixes. To keep the lighting constant, he uses a warm (tungsten not daylight) flash head to illuminate Danny.

Although he usually works on canvas, Nick paints on board today because the rigidity works better with the easel he has. The undercoat on the sanded MDF board is pale blue, a mixture of acrylic primer and blue acrylic paint. The blue works well with skin tones because the translucency of his paint lets it glow from underneath to create a greenish tinge, perfect for shadows and tones. It also allows him to paint both lighter and darker because it is a mid tone. He likes painting portraits in a landscape format, with the sitter off-centre, as the empty space creates a tension and an underlying feeling of a narrative.

His palette is divided into white and primary colours and raw and burnt umber, which work powerfully against the blue of the background. Nick uses a variety of brushes to affect depth and perspective: at the moment he likes using flat synthetic brushes by Pro Arte and round-tipped needle brushes for the finer details.

Today Nick will work mainly from life but will occasionally refer to photos. The photos are mainly there to aid Danny in finding the right position again after breaks. He finds the camera a useful tool in the artist's arsenal in that it can make it easier to see poses that work better than others and is a general aid to getting the drawing right. The drawing is important, but ultimately it's the final painting that counts. Generally, he feels the artist should adopt technology if it makes for a better painting, but finds it odd when artists ignore the sitter in front of them in favour of their iPad or photos. Danny is here today so it would be a shame not to capture his 'aliveness'.

FOLLOW NICK'S TECHNIQUE

DECIDING ON THE COMPOSITION

Taking photos helps Nick narrow down what kind of pose and image he wants and helps him see what does and doesn't work. Having taken several shots of Danny, he looks at them, and adjusts the lighting, on the computer until he finds what he wants. Although he will work mostly from life, he finds it helpful to have another reference point. The photo is also useful for Danny, to help him find the same pose after a break.

NICK'S TOOLKIT

Nick likes drawing and will start his day with a couple of quick, small sketches, the first with a black HB pencil, the second using a brown Rembrandt one.

SURFACE MDF board primed with white acrylic primer mixed with blue acrylic paint

PAINTS Acrylics mixed with acrylic medium gel and liquid copolymer emulsion

BRUSHES Flat synthetic brushes in a range of sizes to give a sense of depth and perspective plus round-tipped needle brushes for fine details

COLOURS Red, blue, Yellow, White and Raw and Burnt Umber

SIZE 41 x 51cm

2

3

MAPPING OUT THE PORTRAIT

The second sketch is more detailed and takes 10–15 minutes. Nick stands up and uses a brown pencil on slightly larger paper. Although he jokes that it's just another form of procrastination, the sketch helps him map out the painting in advance. If he can get the likeness in the sketches, he knows he can get it in a drawing. He measures constantly, using his pencil. He starts with the left eye then moves down to the nose and puts the right eye in line. Once the nose is in, he can start measuring down to the mouth: these are all mapping points. He finds it harder to get the right angles and proportions with the chin and forehead.

THE FIRST SKETCH

It takes Nick ages to get going and he has a routine – a sort of mental checklist – that he goes through before he can start painting: putting the paint out (blue, then red and then white), sharpening his pencils, etc. The first of two sketches he will do today in preparation for painting is a super-quick, five-minute one just to map out the composition and help him see what's going on. (Does he, for example, want to turn the board portrait-shaped after all?) For this, he sits down and draws in an A6 book using a black HB pencil, with which he can get nice smooth shadings if he uses it flat.

4

PLANNING DEPTHS AND CONTRASTS

The brown pencil is very soft so he can make really light marks on the paper and adjust the pressure to create different depths and contrasts. It also feels more playful, less strict – more like being a kid in primary school colouring in, he says – and it helps him look at the transitional tones on the face and features.

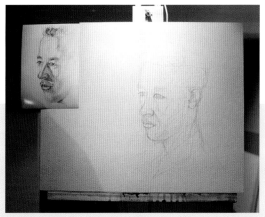

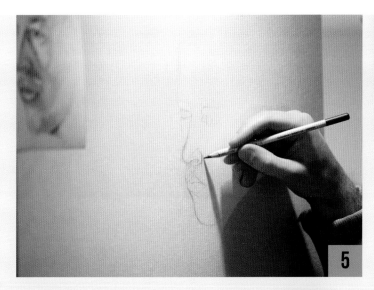

5

DRAWING ONTO THE BOARD

The sketches finished, Nick begins drawing straight onto the board, to the top lefthand side of which he has pinned the second sketch. He puts down lines as markers as he measures the proportions of the face and shoulders. Once he has drawn out the face on the board, he replaces the paper sketch with a photo close-up of Danny's face. Working from life, you can get a bit blinded by what you're seeing, he explains, and it's useful to have another reference. He's extremely nervous because it's been a while since he's done a painting from life but he removes the photograph once he feels more confident and then concentrates on working from life.

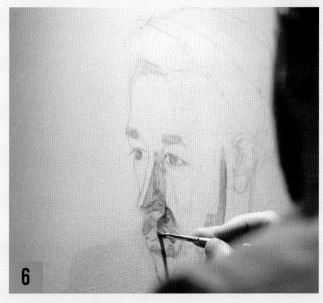

6

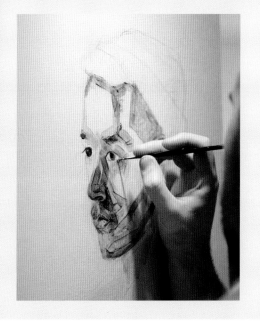

PUTTING DOWN SHADOWS

It is 3.15pm before Nick finally begins painting. He stands up and maps the shadows in as quickly as possible, starting with dark browns, which he paints on thinly, followed by reddish browns. After he's mapped out a few shadows and darker skin tones, he puts in the eyes before moving on to lighter skin tones.

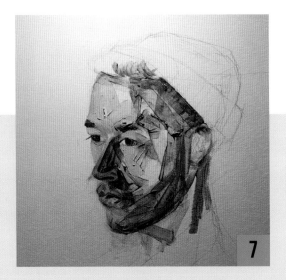

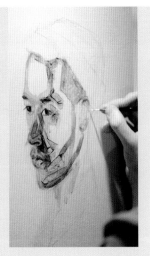

BLOCKS AND LINES

Nick works in jagged, graphic lines, with no soft curves. He has always liked making things in a 'blocky' manner. When he started off painting, he tried to do Renaissance-style smooth painting but he got bored with it and wanted to experiment. He started to put paint on thickly and then the opposite, thinning it right down.

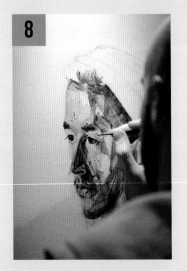

FINDING A LIKENESS

There's a clear likeness already but Nick is unhappy: he's finding it tough not having worked from life in a year and feels the chin, the nose and the eyes aren't working. He wants to get the main features done first then he can play around with everything. After adding fine reddish lines in the nose and eyes, he starts to think it's getting there.

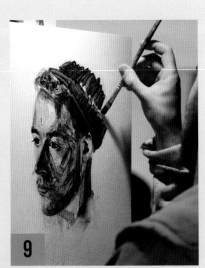

HAIR OR HAT?

Painting hair, can make or break an image completely, he says. After a short pause and adding more skin tones, he decides to put a hat on Danny. He doesn't differentiate a huge amount between fabrics, for example on the hat, and the skin.

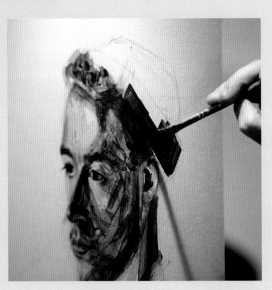

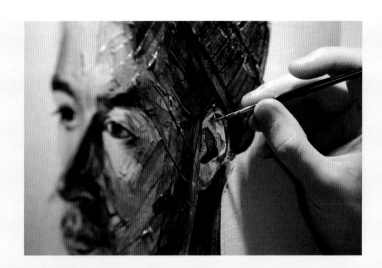

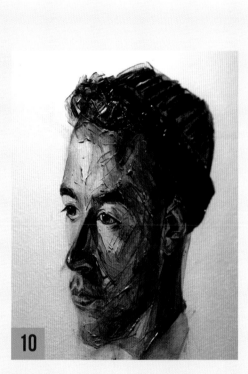

10

FINETUNING FEATURES

Now that he's got the whole face in, Nick moves on to more detailed work on individual features, such as the ear. For his he uses a very fine, round-tipped needle brush. Close up, the texture and construction of the paint, so important to Nick, become very apparent.

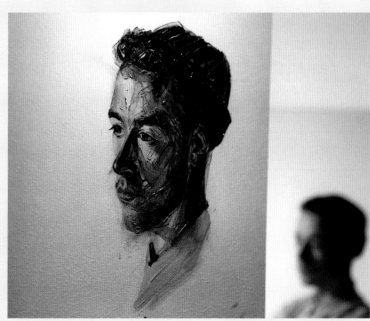

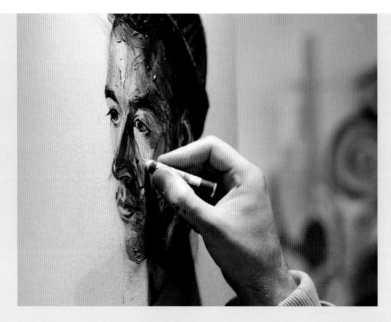

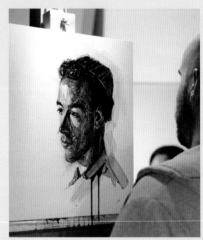

CREATING DRIPS

Nick paints in the shirt. The drips here are thick. Although drips in his work started off as a side effect of thinning paint down with water, he now uses them intentionally. Seen from the side, the painting reveals the thickness of the ridges, lines and drips Nick creates with his paint mix.

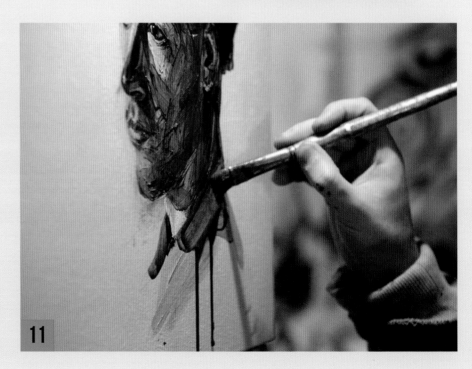

11

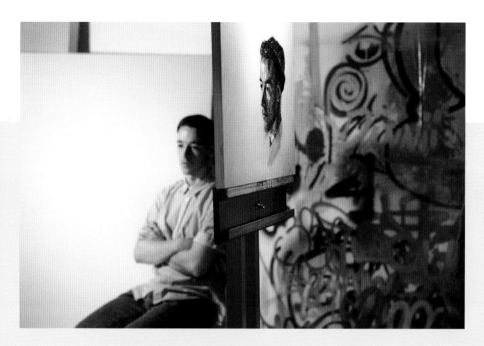

WASHING THE BACKGROUND

The thin wash that Nick paints around the head into the background is purely to break things up – he had already primed the board with a very pale blue wash prior to painting. He smudges this wash so it contrasts with the crisp lines of the face.

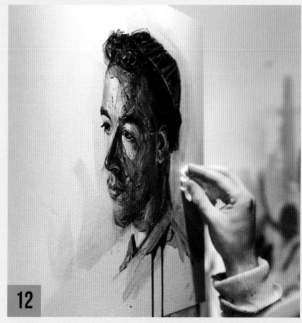

12

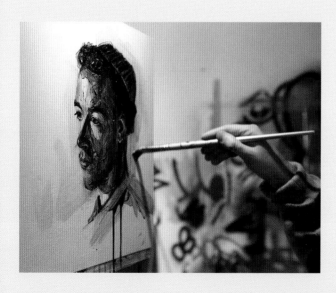

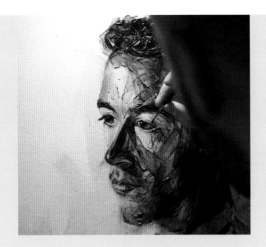

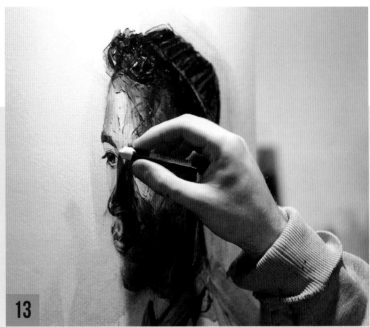

13

TIDYING THINGS UP

When he's making mistakes rather than doing anything good, Nick knows it's time to stop. All it takes is one or two brushstrokes to make it or break it, ruin it or fix it. Just a few touches to the eye with a needle brush and a few highlights and he's satisfied.

'WHEN I LOOK AT A PAINTING, I'M LOOKING AT HOW IT'S BEEN PAINTED. I WANT TO SEE THE TEXTURE AND CONSTRUCTION OF THE PAINT.'

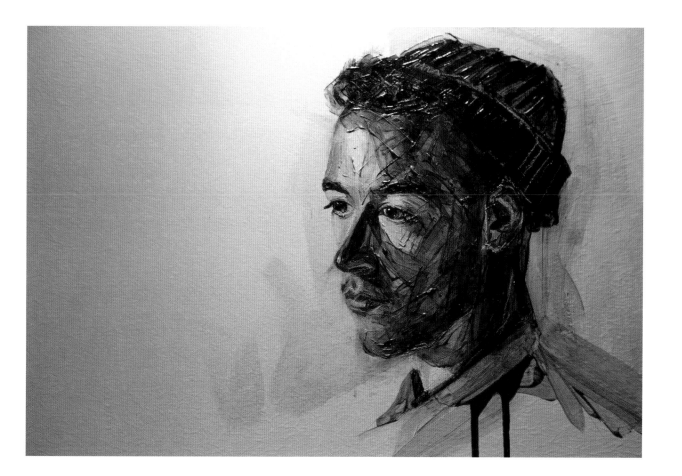

AINE DIVINE

Aine, who participated in both years' competitions, is an artist and art teacher based near Edinburgh and is a rare but much-prized watercolour portraitist. Watercolour as a medium is often considered to be slight and lacking in depth due to the transparent, ethereal way it has to be applied, but Aine's work belies such a prejudiced view: she produces portraits with great emotional heft, and watching her work was a revelation as to what a tough and resilient medium watercolour can be. Her insightful portrait of the musician Neil Hannon during her heat was just the start of a string of great portraits that saw her through to the final.

A Good Portrait

Much of what Aine says about the making of portraits is concerned with the artist's state of mind and receptiveness to the model and the qualities of the day. 'It almost feels like a holy process; it's a privilege to gaze at a person for that length of time and only moment by moment record what you are seeing. It's a refreshing thing to do. You don't often get the chance to be that still in modern life for that long with someone else, just looking and observing … and be that curious for long enough!' She thinks the biggest challenge is to be relaxed and focused enough to properly look at the sitter, although in a dispassionate way and not chasing any particular goal. She doesn't do flattery but neither does she play with ugliness in her portraiture. As for likeness, 'We all see people differently and have different ways of pulling something out of the person. What I seek is my own expression and essence of that moment in time – it can differ throughout the painting'. Aine prefers working directly from the sitter, as one can observe life happening over the course of the day, although she has also worked from photographs when doing commissions. She has even painted from photographs of deceased, where the family have felt she captured a likeness better than a photograph could.

Influences

Aine's influences reflect her attitude to art in general rather than her preference for any specific medium, she admires Rembrandt for the 'soul' embedded within his work and Matisse for his interesting concepts about art; for example, 'exactitude is not truth'. She likes Mary Cassat for her use of the mother and child relationship as a subject, her lovely treatment of edges and the general unfinished, dynamic quality of her work. She finds admirable Joan Eardley's openness and willingness to respond to whatever medium works for each individual painting – or had been swept into the process, such as grass and sand. A recent loosening-up in her own work is partially inspired by a quote by Paul Klee in which he exhorts artists to 'make chance essential'.

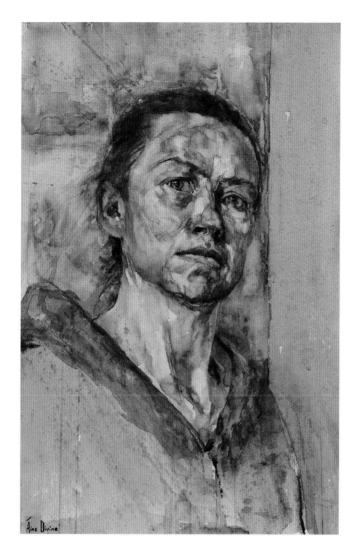

SELF-PORTRAIT
AINE DIVINE

Style and Technique

Aine also works in oils and acrylic but prefers watercolour. She likes the fact that portraiture in watercolour has no track record, tradition or boundaries that you have to remain demarcated within: you can make your own rules. It is all about layers in watercolour, and letting the white of the paper and the water do the work. As the colours dry, they become lighter, and change hues, so it is necessary to keep adding paint layers to keep playing with the painting's contrast. Other watercolour artists use masking fluid to keep their whites white, but Aine says it doesn't work for the way she paints: as it would feel like colouring in around blocked-off areas. Instead, she likes working more organically, putting paint on and lifting it off if necessary. She uses the sharp edge of a cheap craft brush, or some tissue, to lift the paint off and get back to the paper. As she works the surface quite hard, her paper of choice is Bockingford 535gsm, which she tapes to a board. She finds stretching paper an awkward process and reserves its use for smaller formats.

Aine is a very physical painter in that she stands up and uses her whole body when at work. She will warm up by doing a few charcoal drawings to work and feel her way into the painting process. It is also 'a way into looking' and helps her establish the ideal composition and pose. She usually starts with the dark areas of the figure, blocking in the big shapes first of all. It is a vigorous balance of drippy, splashy paint and careful observation through a viewfinder and some measuring by eye and occasionally with her brushes. Aine also controls the running paint by turning her board upside down, diagonally or onto its side so that the paint drips in the direction she needs it to – often, along contours, and away from areas of colour she wants to keep clean – it also helps her see more analytically by making her observe the picture from a different angle (other artists use mirrors to this purpose). She also continues to work on the paper when it is in these unorthodox positions to keep things fresh. She describes her process as akin to dancing a tango.

Today's Portrait

Today's model is Lake Montgomery, a Texan singer-songwriter whom Aine has already painted a few times and with whom she has a good working relationship. After some costume changes, it is decided that Lake will wear a blue headdress and top and will pose in the kitchen, which is where Aine usually paints, as she is accustomed to the light conditions and colours there. To make absolutely certain that the light doesn't change throughout the day, she has placed a large modelling light outside, so it shines through the window. The kitchen behind Lake is cleared of any visual distractions and Aine then carefully sets up her easel so she has a clear view of her model from the edge of her board and enough space behind her so she can step back and appraise her work from a distance. She prefers a portrait format for its dynamic verticals.

Today she is working with two small palettes, and the colours, made by Winsor and Newton, are her trusted eight she habitually uses when not experimenting: Viridian Green, Alizarin Crimson, Cadmium Red, Lemon Yellow, Ultramarine Blue, Vandyke Brown, Cadmium Yellow and Cadmium Orange. Sometimes she adds Sap Green too. She uses a large brush for blocking in and a medium-large square flat brush for slightly smaller shapes. Good for sharp decisive marks and lifting off is a cheap craft brush, and for the details such as eyes, she uses size 8 round brushes. She doesn't mind if they are sable or synthetic. For cleaning brushes and lifting off, she uses copious amounts of kitchen roll. To protect herself from distraction, she works throughout the day with her headphones on.

FOLLOW AINE'S TECHNIQUE

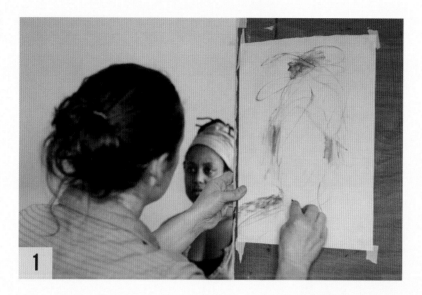

CHARCOAL SKETCHES

Aine likes to start the day with a series of quick charcoal drawings. It's a process that serves both to warm up the body (she's a very physical painter who moves around a lot while working) and she finds that it helps her to find and build the right composition. She gets her model to change her pose and simply reacts to what she sees. The sketches get progressively longer, as well as more instinctive – for example, she occasionally draws with her left hand – as she goes along.

AINE'S TOOLKIT

Although she is branching out colourwise, using more vibrant reds and oranges, generally Aine prefers to stick to the eight colours she normally uses when she is in a pressurised situation.

SURFACE Bockingford Watercolour Paper 535gsm

PAINTS Watercolour

BRUSHES Large and medium-large square flat, cheap craft, size 8 firm round

COLOURS Viridian Green, Alizarin Crimson, Cadmium Red, Lemon Yellow, Ultramarine Blue, Vandyke Brown, Cadmium Yellow, Cadmium Orange

SIZE 75 x 55cm

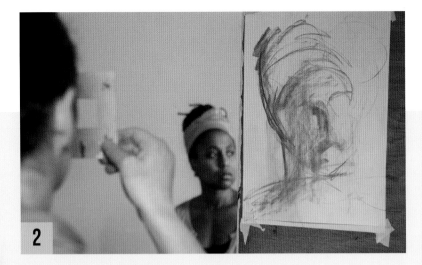

CHOOSING THE COMPOSITION

She captures sweeping statements, dynamic movements with these charcoal sketches; they are the scaffolding to which she can build the portrait around when she begins painting. In order to see the big shapes, she half closes her eyes (to avoid any specific detail), and blocks in the large shadows. She likes to work from the shoulders up. After looking at it through the viewfinder to frame and see the spaces around her model, Aine chooses the fourth sketch she has created.

SELECTING BRUSHES

Aine is happy using either synthetic or sabre brushes. She selects a large brush for contours, medium–large square flat brushes for slightly smaller shapes, cheap craft brushes with a razor sharp edge for square decisive marks and a size 8 firm round brush for more detailed parts of the portrait, such as the eyes.

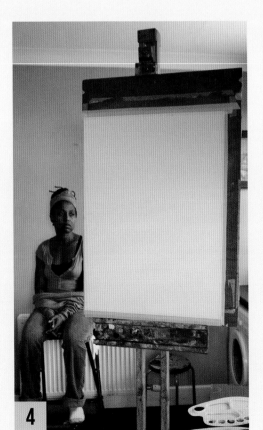

SETTING UP

She tapes her watercolour paper onto the board and takes time to set up at the edge of the board so she can see both the model and the painting easily and familiarises herself with the space. She practises her position so she knows where she is going to be at same point when viewing.

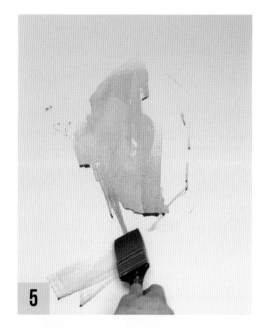

5

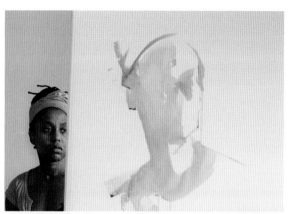

CAPTURING THE CONTOURS

Aine generally starts with the dark side of
the face. She mixes an orangey brown and,
using the edge of the large brush, precisely
captures the contours of the face. She
checks the viewfinder. Big shapes go in –
dripping down, splashes dotting around.
She applies a darker brown then puts in
the other profile edge.

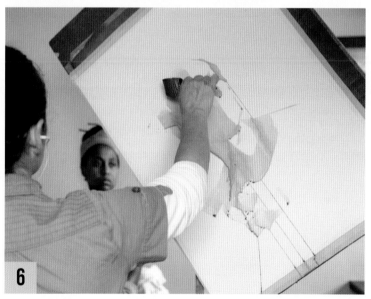

6

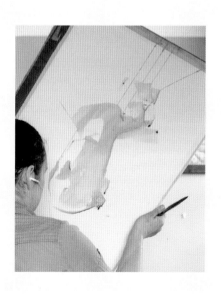

TURNING THE BOARD

It is time to turn the board at an angle. This helps Aine
to get away from the image and see in a fresh way and
helps her to avoid preciousness. Constantly moving the
board also stops her applying too much paint – which
can be particularly hazardous when using watercolours
– and it allows the paint a moment to dry. It also affects
the direction of the line that the drips run in and plants
the sitter in a space. Aine likes the direction of the paint
running diagonally, so encourages the flow of the paint
that way by turning the board in that given direction.

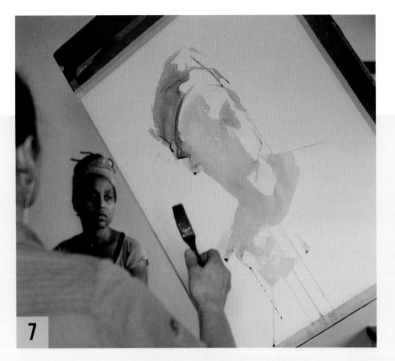

ADDING COLOUR

Colour is specific to what Aine is seeing, even at this point. She continues with the dark sides of the face and then puts the third block colour in: the blue headdress. From there, she will move onto the purples in it and in the dress.

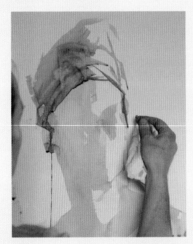

PAINTING UPSIDE DOWN

She adds more brown, again turning the painting onto its side, which prevents the paint dripping into areas she doesn't want it going into. When painting upside-down, she is measuring according to where she thinks things are – she works out distances and normally draws accurately when working upside-down but sometimes finds, when she turns the painting the right way round again, that it's all in the wrong place. Where she makes a mistake, for example, a blue line going over the face, she just lifts it off with a piece of kitchen paper.

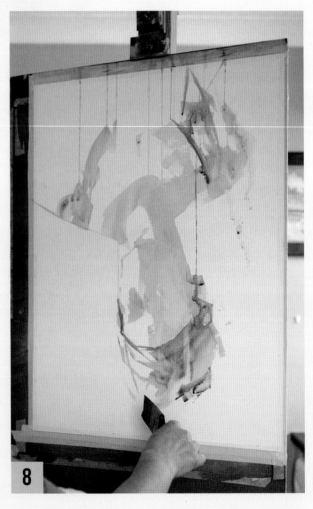

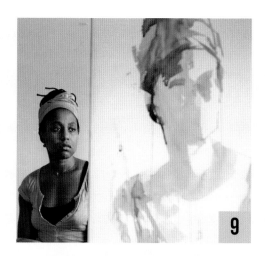

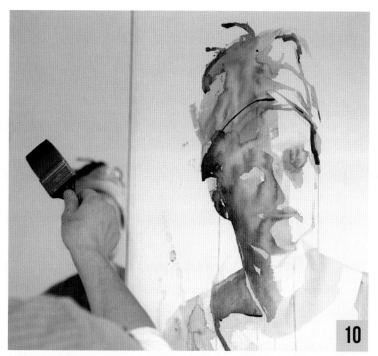

BRIGHTENING AND LIGHTENING

After turning the painting the right way up, Aine can see it afresh again – time and position have changed her view on it. She then applies further reddy-purple tones and more hard edges. She waters her paint right down for the lighter areas to build contrast between these two areas of the portrait.

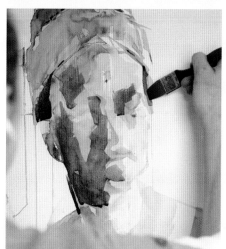

DARKER AREAS

Then the darkest areas, such as the hair and the strong blue on the headdress are added. As watercolour paint dries it dulls, so she has to keep brightening it up and revisiting it. She measures distances casually with her brush rather than a stick.

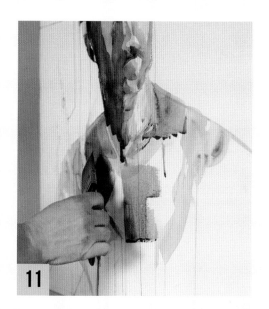

ADDING SWEEPING CURVES

Having changed to a medium brush for the thicker, rich brown contours and black hair, Aine takes up the large brush again to add sweeping curves of colour, contouring the brown neck and adding touches of bright turquoise and yellow in the neck and top.

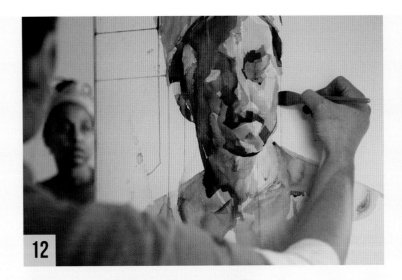

12

SPLASHING AND DRIPPING

She splashes on blue and flicks the paint to create a mottled effect. She wants the drips to go in the direction of the body. She was inspired to do this by Paul Klee – it's all about 'making chance essential' – as you can always create something brilliant with mistakes. Dripping has always been part of her work, splashing more in the last few years – it allows her to loosen up her painting style and not be too controlled. Her favourite quote in her classes is: 'You can make a wild goose tame but you can't make a tame goose wild. It's a good thing to make a mess – it gives confidence and freedom!'.

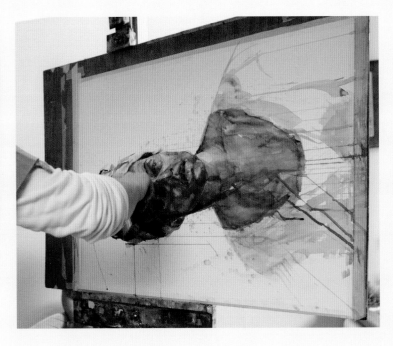

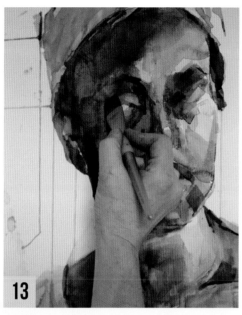

13

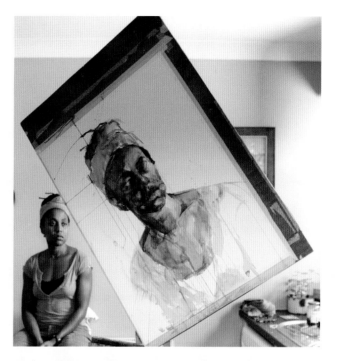

DEFINING FEATURES

After lunch, Aine needs to work on more dark shades on the face to make them more pronounced as the paint has dried to a lighter shade. She also still needs to work on the eyes. After painting the left eye, she quickly turns the canvas round to keep water out of the eyelid. The lines of dark paint she has added are now starting to define the features and the portrait is coming to life.

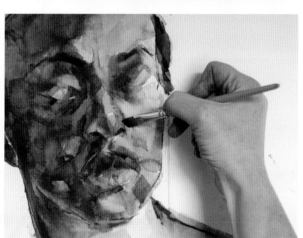

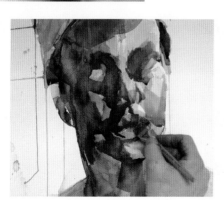

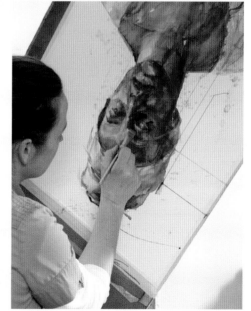

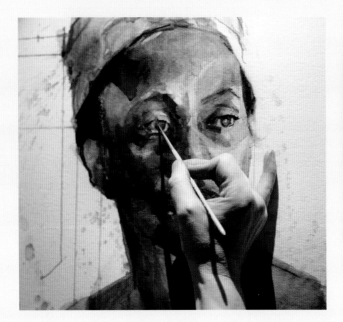

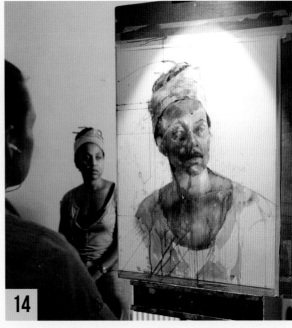

14

> 'YOU CAN MAKE A WILD
> GOOSE TAME BUT YOU CAN'T
> MAKE A TAME GOOSE WILD.
> IT'S A GOOD THING TO
> MAKE A MESS – IT GIVES
> CONFIDENCE AND FREEDOM!'.

ADDING THE FINAL TOUCHES

As it begins to get dark outside, Aine brings a little light in and drops the easel to attach it to, so she can begin to see what she is doing and pick up the texture of the paper behind the paint to add depth and physicality to the face. It also bathes the painting in a warm colour. She adds definition to the eyes using a size 8 fine round brush and, after contemplating the painting, resolves the ear and left side of the face. The high visibility the light provides allows her to work with the texture of the paper and the paper, creating deep textural relationship between the two. It creates an almost 3D appearance to the finished portrait.

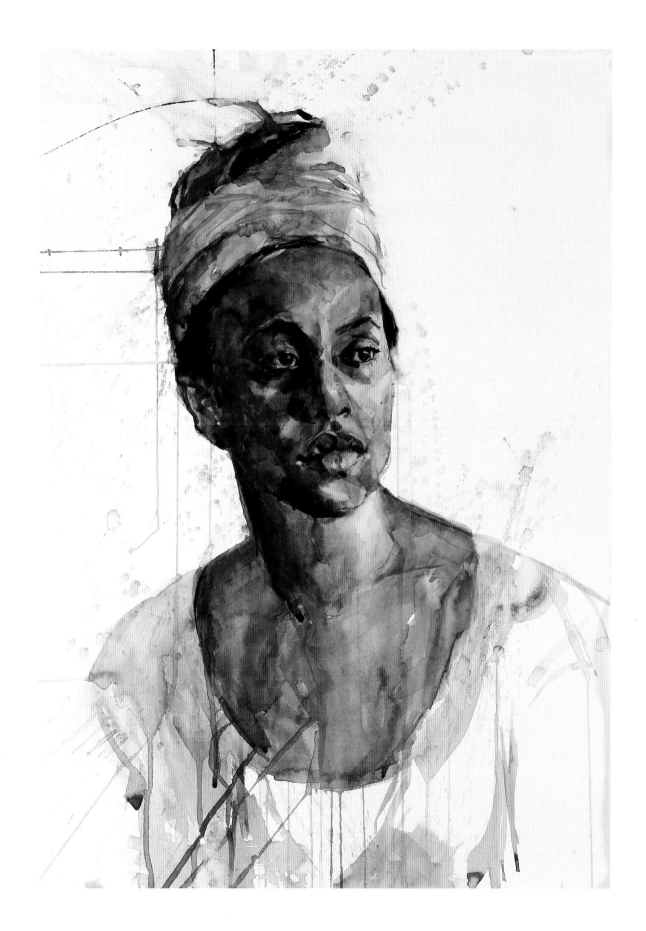

ROSALIE WATKINS

Rosalie, who studied and now teaches at the Lavender Hill Studios, an art school that bases its teaching methods on traditional atelier methods, made a beautiful portrait of the actor Alison Steadman during the very first heat of the Sky Arts portrait competition. The likeness was astonishing and was realised in a painterly yet economical way; its unfinished state added to its vitality.

A Good Portrait

It takes more than a good likeness to make a good portrait, which should be a beautiful painting in its own right that also captures the person. Rosalie says she is drawn to portraiture because it is about people and humanity, which is such a rich subject. The beauty of every subject can be revealed through paint in a powerful way if the artist has soul, she believes. Although the model is obviously important to the process, Rosalie doesn't really have a preference of a type of sitter as she approaches a painting from quite a technical point of view. It's about masses of light and dark, tone and colour: 'I design the canvas as an image before I think of it as a portrait.'

She also tries to find an appropriate pose to capture the sitter's personality and carefully arranges the lighting to create interesting planes and shadows on the face that help to make a convincing likeness. By changing the lighting, point of view and pose you could endlessly make interesting portraits of the same person. When painting, she says, 'You paint what you see and you focus on something that excites and moves you, and what comes out is a by-product of that… What comes out is subconscious; you don't set out to flatter or anything.'

Influences

Rosalie likes the paintings of Velázquez, Anders Zorn and Sorolla, all masters of simplifying a subject and seeing so abstractly that even the most intricate head or hands are made with very few brush marks, but marks so absolutely correct in terms of colour, tone and placement that when one steps back one knows exactly what is being depicted.

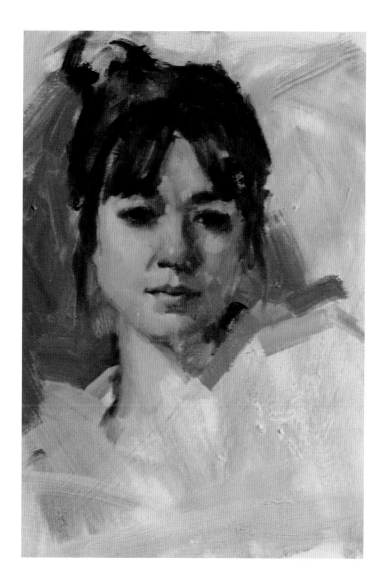

SELF-PORTRAIT
ROSALIE
WATKINS

Style and Technique

'I prefer oils because of the longer working time and richness of colour and its potential for making different transitions. Also it is more forgiving, so if I mis-hit an edge I know that I can paint it back from the other side.' She prefers more expensive paints as they are richer in pigment and give cleaner flesh tones when mixed. Before embarking on a portrait, she will do a lot of compositional sketches to work out the pose, relationships and flesh tones and the value patterns – the arrangement of the different tones over the face. If she leaves a bit of time between preparation and the actual painting of the portrait, it gives her time to process the information, which becomes invaluable later. Although linen is considered a more sophisticated surface on which to paint portraits, Rosalie prefers working on medium cotton because of its lightness and springy nature. She starts by drawing the structure of the composition onto the canvas with thinned oil paint, placing

the model, mapping the planes and marking where light and dark meet. She approaches the head methodically by putting it down as an egg shape with a centre line and different marks at intervals indicating where the eyes, nose and mouth are. This way, she can make sure that the angles are correct whichever way the head is tilting but can also capture the likeness with minor adjustments to these proportions. She states, though, that 'People think the likeness is in the eyes – it's not; it's in the mouth. If the mouth isn't right, the likeness isn't there'.

Today's Portrait

The light is set up to accentuate the clear planes of the face and Sally has a clearly defined bone structure. Although, unlike artificial light, natural light isn't controllable, Rosalie prefers it for the way it provides a purity and richness of colour and lets the flesh tones sing; light from north-facing windows provides the most constant light and gives the longest option for working hours. She chooses a neutral, dark blue-grey background as it doesn't bounce back light. Although Rosalie likes painting profiles, she chooses a three-quarter pose because it describes more than a profile but is more interesting than just straight on.

She works with a limited palette, meaning she only uses White, Yellow Ochre, Cadmium Red and Ultramarine, plus a bit of Oxide Brown to make her flesh tones. This way she avoids the trap of overthinking colour in the early stages and concentrates instead on lights and darks, the tonal pattern. She favours flat hog-hair brushes with long handles. Rosalie used to work with music playing in the background but now prefers to work in silence, and although she finds talking to the model helps keep them animated and the face alive, it is important for them to hold the pose at all times.

FOLLOW ROSALIE'S TECHNIQUE

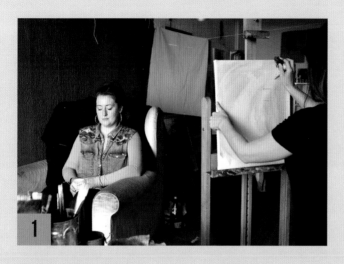

WASHING THE CANVAS

Because she's posed her model in front of a dark neutral background, Rosalie wants to kill the white background of the canvas, which she does by putting a light greyish wash over it. This must not be so wet that it's dripping, but nor does she want it to be so dry that it's dominantly dark. She tissues off the excess turps until the canvas has a tone and temperature she's happy with.

ROSALIE'S TOOLKIT

Rosalie favours expensive brands of oil paints because they're thicker, have more intensity and, for flesh, are just really clean. She uses a limited palette, feeling she has enough scope to get everything she needs without being overwhelmed with too many choices.

SURFACE Medium cotton canvas

PAINTS Oils

BRUSHES Long-handled hog-hair brushes, particularly flats, but she has a large collection and uses whatever is appropriate

COLOURS White, Yellow Ochre, Cadmium Red, Ultramarine, Oxide Brown

SIZE 41 x 51cm

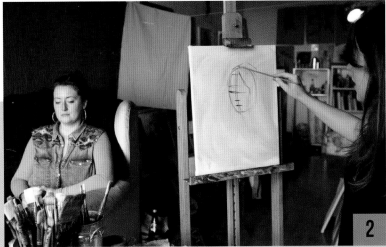

PLACING THE FACE

Having already spent time thinking about the pose and the composition, she already knows where the head is going to go. She can therefore start immediately on mapping out its structure with lines made using a thick, transparent, browny blue wash. She draws an egg shape (the top of the which is the cranium not the hairline or forehead) and marks a line halfway down for the eyes, dividing the lower part in two for the nose, and doing the same again for the mouth, then adds a centreline through the eyebrows, nose, septum and chin. She will make adjustments later but finds it useful to have these markers acknowledged from the start.

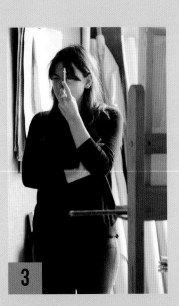

MEASURING AND VIEWING

A mirror is the only prop she uses to measure, and she uses it often. It flips everything into reverse and enables her to be her own best critic and see the painting afresh. ('I have come through a training where the more your eye can lock into shapes the less you need any measuring devices/crutches, as you trust your eye.') It takes her about 10-15 minutes to complete this line stage.

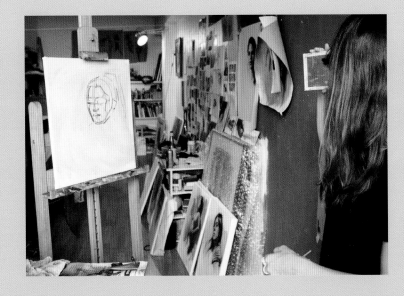

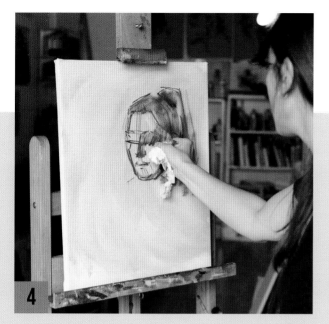

4

SHADOW SHAPING

She squints to simplify the light and dark, looking closely at the sitter and putting in the darkest blocks and the hairline – always adding big elements before small. She wants to make sure she has the structure in place before she starts adding any detail. This is a learned concept, she says: most painters she admires – Sargent, for example – lock in the dark like this. Once she has the darks down, she can see if she has a likeness of the sitter. She's put things in lightly so she can just move light and shade around. The more abstractly you approach it, the more helpful it is, she says.

ADDING COLOUR

She still doesn't want to overthink colour, most important is to maintain the correct light and dark relationship and pattern; it's still just about dark, transparent marks. The colours don't matter at this stage. The layout of the palette is transparent to opaque and dark to light. White and ochres act like milk in tea, they are opaque so whilst working in the transparent stage she doesn't use them. When that stage is over, she can start to put colour in.

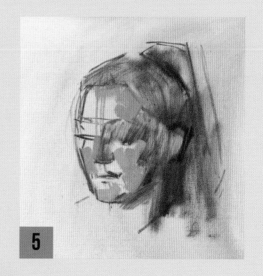

5

KEEPING IT FRESH

Taking frequent breaks from painting are essential for Rosalie: she finds she needs to stop every twenty to thirty minutes or so in order to keep things fresh. She uses the time to scrape down the palette, put new colours in and wash her brushes.

6

STEPPING BACK

Rosalie paints with her arm stretched full out, keeping her distance from the painting as much as from the sitter. Brushes with long handles really help with this, but she needs to constantly step back to compare her subject to the painting, too.

7

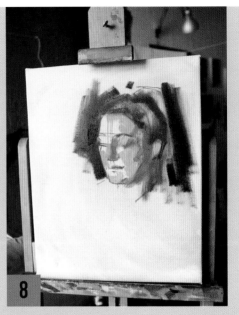

8

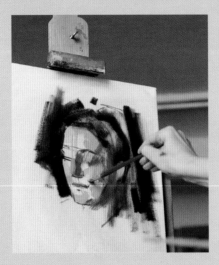

FRAMING THE FACE

Because Sally is surrounded by a dark background, Rosalie wants to lock that in before adding any more detail to the skin tones on the face. She paints a dark ultramarine around the head, which creates a sharp edge on the left-hand side of the face.

WORKING ON SKIN TONES

She continues to add tones, correcting what is there, adding cool and warm tones and trying to get the shapes as accurate as possible. She blocks off a warm, quite bright, rich peach on the cheeks and the side of the nose, then moves onto a lighter, cooler, duller shade on the forehead and chin, followed by a mix of both on the other side of the chin. Tones are generally warmer in the mid part of the face because of the blood supply, while the forehead and chin are usually cooler, but Rosalie stresses that it's important to go with what you see rather than get hung up on the theory.

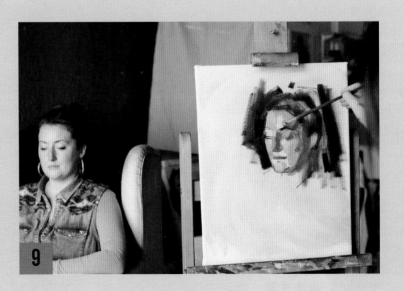

9

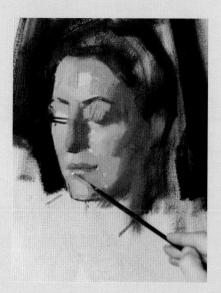

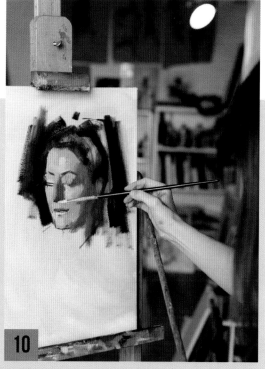

10

ADDING DETAIL
As she begins to work on finer details, Rosalie decides to use a mahlstick to support her painting hand.

CONTAINING THE IMAGE
Rosalie knows that she's not going to be able to flesh out the portrait in the time she has. This is a head study really and it's looking lost on the canvas. She mulls over whether or not to crop it for a long time, trying a border around it to see what it looks like.

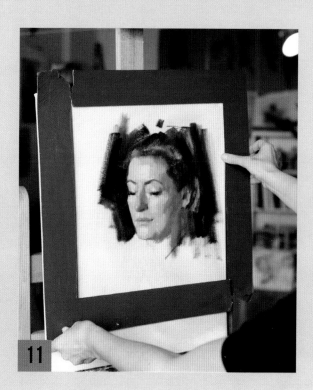

11

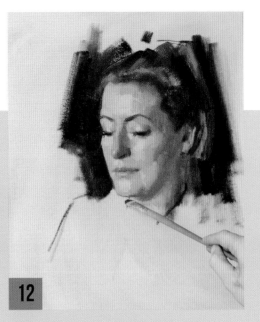

12

ANCHORING THE HEAD

Looking at the portrait more closely, Rosalie decides that she needs to put some dark on the neck to anchor it. (Normally, she would go away from the painting and then add this first at the next sitting.) She proceeds to add a touch of dark that instantly has the desired effect. She also puts in a bit of shoulder but then changes her mind and rubs it off.

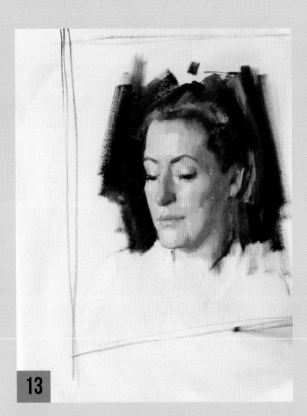

13

DECIDING ON THE CROP

Rosalie marks lines on the canvas where she would crop it – purely 'where it feels good'. She's aware that she's playing it safe today: she could have chosen to flesh out the portrait more but doesn't want to take the risk of spoiling it. However, for a day's work, she's happy with this head study, she says. 'In my head, I had time for a head. That was my game plan and I think this is an honest early stage.'

> '**I DESIGN THE CANVAS AS AN IMAGE BEFORE I THINK OF IT AS A PORTRAIT.**'

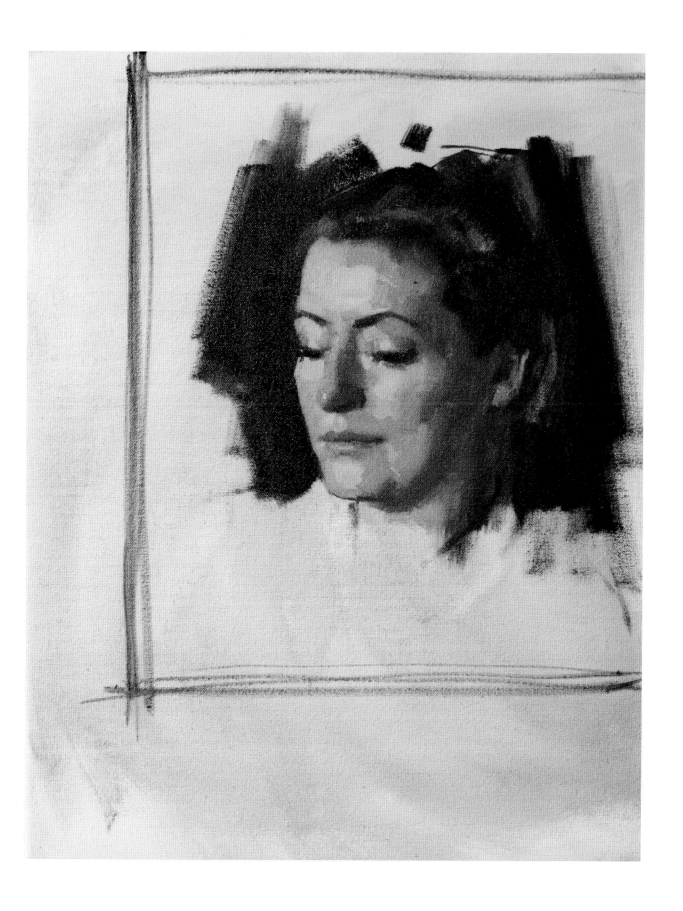

DAVID THOMAS

PAINTS IN WATERCOLOUR

David trained and worked as an architect but has always drawn and painted –
he took early retirement in order to devote himself to his art. Not having studied
at art college, he considers himself a self-taught artist and has picked up skills
from all sorts of sources, including books and painting holidays. The self-portrait
with which he entered the competition impressed the judges with its superb
drawing and incredible luminosity, indicating great mastery of that rarity, the
watercolour portrait.

A Good Portrait

David says that when painting a portrait, he approaches a face or hand as he does
anything else; he has no truck with psychological insight and considers that when
people react to his paintings in this way it must be either a coincidence or their
fanciful natures. He is challenged by and attracted to people's faces but doesn't
expect to reveal anything about the person other than what is present in front of
him. Like some of our other portraitists, he identifies the mouth as the critical
feature when looking for a likeness. When it comes to commissions, he admits
to feeling a responsibility to the sitter and, though he thinks it natural to want to
show the sitter in their best light, he doesn't flatter consciously.

He feels very strongly that watercolour has been neglected as a medium for
portraits, despite the historically strong watercolour tradition in England. 'I
will always defend watercolour as a good medium for portraiture, especially for
children, because it has an inbuilt subtlety of tone and colour – you can let it fuse
and that gentleness works for you. You need to control it, obviously.'

Influences

As David also paints landscapes, he likes artists who are strong in this field, too.
He admires David Curtis for the excellent draughtsmanship that underpins his
work, William Russell Flint for his wonderful watercolour skills and Roland
Hilder for the looseness of his sketches. He is currently very drawn to John Singer
Sargent, not only for his ability to capture a good likeness with apparent ease but
also for the expressiveness of his marks. David has recently started doing more
drawing in charcoal as he likes its tonal subtleties and range, and in this medium,
too, Sargent proves to be an excellent role model.

Style and Technique

'Watercolour suits a certain temperament, e.g. the mercurial, because it is so quick,
one is always on the edge of losing control.' He starts by drawing the composition
accurately with a pencil: everything else relies on this correct foundation.

He has always been a good draughtsman, with natural hand-to-eye coordination, and used to presume that everyone had this innate ability, but he now thinks it is a talent, a bit like musicality, that you are born with. When he first started painting as a hobby, he had to make a conscious effort to loosen up his painting (without losing accurracy) as he was still practising architecture.

Although he does life painting and life drawing every week, David also likes to work from photographs and, like many artists, is quite conflicted about using technology. Although he now works from a digital image plugged into his TV via a laptop, he does insist on working from his own photographs: he feels it is just merely copying if he hasn't had any contact with the subject, and it makes him feel more at ease when he can empathise with the sitter in the process of painting them.

Watercolour is more flexible and forgiving than people think in that you can correct mistakes by lifting the colour out again with a sponge or paper. He doesn't use masking fluid in his portrait work, but on the occasions that he loses the white, he adds a bit later. 'Watercolour dries lighter, which can be a blessing, but it often means it's hard to put down anything too dark. This fading means going over the same areas, intensifying the colour and shadows as often as necessary to model in the shapes.'

Today's Portrait

The sitter is David's retired friend Bob. He has an interesting, thoughtful face that is good to paint and they are obviously close and supportive of each other. Bob is there in the beginning and comes back at the end, but for most of the day David works from a digital photograph streamed to his TV screen. The sitting takes place in an east-facing room with large windows in David's house in Yorkshire, which is full of his paintings and inventions. One of these is his 'Paintpal', a portable easel/palette/chair, which is a registered design, and today he will be using one that he has had factory-made in China. He takes some photos of Bob in a three-quarter pose right by the window, which gives a good light and accentuates the shadows. He likes indirect natural daylight for its softness, but will augment it with a colour-corrected bulb when the light fades.

He prefers the dynamics of a landscape format and today is using a 15" x 22" half imperial sheet of 330lb, cold-pressed Watercolour Society paper, which doesn't need stretching – it's also the best size for his 'Paintpal'. He generally paints with Da Vinci Watercolours in tubes and uses the following colours: French Ultramarine, Burnt Sienna, Cerulean Blue, Modern Blue, Cadmium Red, Alizarin Crimson, Light Red, Viridian, Cadmium Yellow and Perylene Green. The latter is a recent discovery that he likes for its dark translucent intensity and mixes with Ultramarine when he needs an extremely dark tone rather than using black. His has several round Kalinsky Sable brushes from Winsor and Newton, but will mainly use a size 8 today – he believes you could comfortably paint a whole painting with just this brush. He also has a squirrel mop and a hake brush for the larger areas. Other than that, he uses a 6B pencil for drawing with and an eraser.

FOLLOW DAVID'S TECHNIQUE

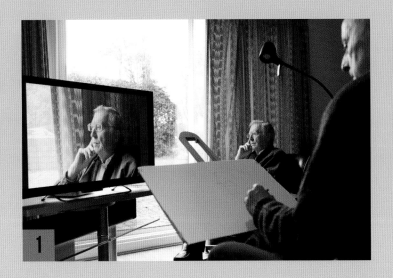

THE PHOTOGRAPH

Although he does attend occasional portrait and life drawing classes, David often works from a photograph he has taken. Today, his subject, Bob, will be there at the beginning and the end of the day. But for the rest of the day, David will rely on the photograph, which he views on the big TV screen linked to his laptop. He tends not to manipulate photos much as he doesn't want to alter what he was originally drawn to.

DAVID'S TOOLKIT

For this painting, David uses a thicker paper than usual – more like card. Generally, he says, the thinner 140 is good enough. He also relies on his 6B pencil (and an eraser): starting with an accurate drawing is crucial.

SURFACE Watercolour Society Watercolour Paper 300lb not pressed

PAINTS Watercolour

BRUSHES Kalinsky sable no. 8 round, plus a squirrel mop and a hake brush for larger areas

COLOURS French Ultramarine, Burnt Sienna, Cerulean Blue, Modern Blue, Cadmium Red, Alizarin Crimson (modern version), Light Red, Viridian, Cadmium Yellow, Perylyne Green

SIZE 35 x 32cm

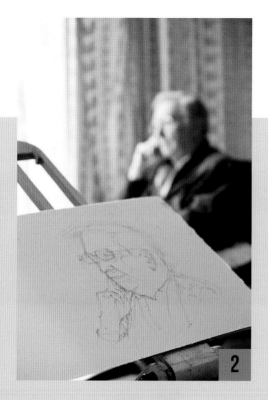

DRAWING THE COMPOSITION

David starts sketching incredibly quickly. Within 30 seconds, he has the basic form of a head and glasses. There's no measuring; he sketches purely by eye. He starts refining the head and shoulders shape then moves on to the details, placing then correcting the eyes, putting down the mouth, etc. He draws the contours of the face in a firmer line, then rubs out the forehead and makes it recede more. He prefers to be highly accurate at the drawing stage and then have the relative freedom of applying the watercolour.

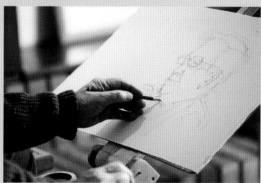

MIXING THE COLOURS

The range of colours that David has mixed will work for most of the face and outfit. Having taken a deep breath ('You have to have guts to be a watercolourist and be prepared to fail!'), David will put these in loosely in lots of areas at first; he can later correct as necessary.

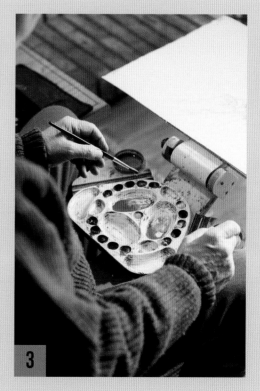

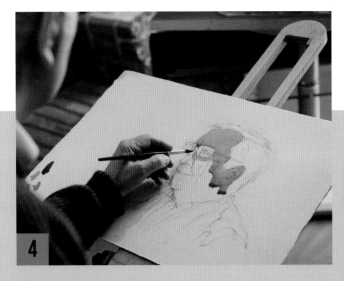

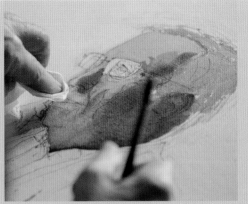

APPLYING THE SKIN TONES

David begins painting by applying skin tones on the face. He then blots the highlight on the nose and the upper lip with kitchen paper, lifting some of the colour out again to keep the edge light, before painting the skin tones on the hand.

ADDING SHADOWS

He moves on to the shadows, applying darks on the shirt cuff and the dark shadows on the hand and side of the face. He uses a small brush to lift off excess paint at the edges where it has pooled slightly. He adds further shadows on the nose and the side of the face, then starts filling in the shirt.

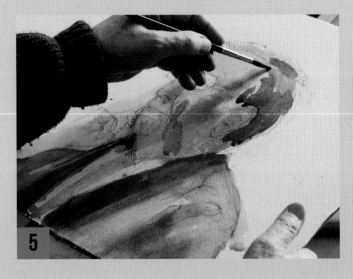

PAINTING THE EYE

David paints in the eye, working from the shapes and shadows of the skin around it. If he can make a really good job of it, he'll feel encouraged, knowing he can do the rest. He often uses his mouth to moisten the brush when painting fine details like this.

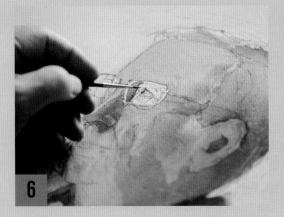

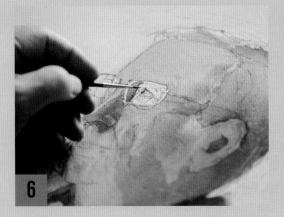

THE PORTRAITS | 70

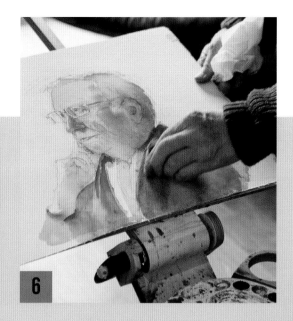

6

BLOTTING OUT COLOUR

David feels that the colours are wrong on the clothing and sponges them out. The quality of the paper determines how tolerant it is of the sponging: fortunately, this paper is good in that respect. You need to use a sponge because the water will absorb the colour and then wipe away again, but sometimes – as happens later with the forehead – he can't get back to the paper as much as he'd like; possibly the sponge was too dirty.

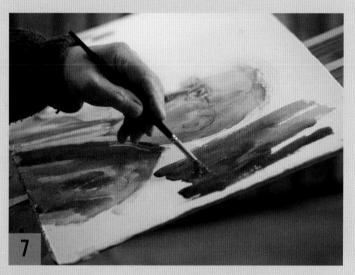

7

SHADING THE BACKGROUND

The whiteness of the paper is distracting David and he feels it's upsetting the balance of the painting. He puts in some red to kill it, but decides that using that red so boldly with a big brush was a mistake and so adds some perylyne green to counter it. He also adds some into the back of the hair as he wants the head to virtually disappear into the background as it does in the photo. He does the same with the top of the shoulder.

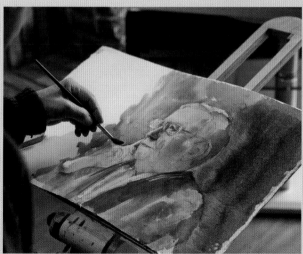

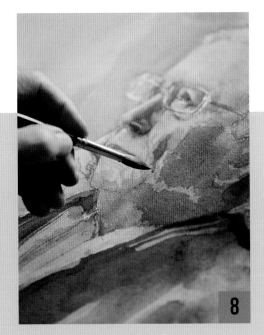

8

INTENSIFYING COLOUR AND SHADOWS

Watercolour dries lighter, which means David needs to go over the same areas, intensifying the colour and shadows, to model in the shapes. The tone values are getting there, he feels, and the colours aren't crucial. It all depends on a good drawing, though: without it, he wouldn't know where he was going. If the pencil marks are obtrusive, he may rub them out, but he tends not to.

DEFINING HANDS AND LIPS

The hand, if well painted, is an important part of this portrait. He moves onto it, applying greeny brown shadows followed by reddy brown ones – and uses a hairdryer to dry the paint. With watercolour, if all going well, the water does a lot of the work if you manipulate it. You just need to steer it roughly in the right direction. Its charm is its running and blending. He puts a bit of white on the lips as he lost the white of the paper.

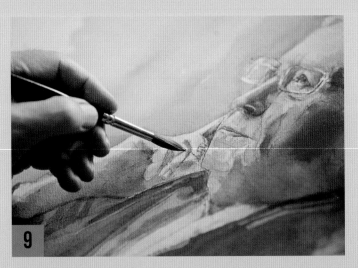

9

HIGHLIGHTING THE FACE

Having put the painting on the mantelpiece to take a good, hard look at it and work out its mistakes, David isn't happy: the painting doesn't look right when seen against the photo. He decides to sponge out the mouth and chin and then to put shadows in the background behind the forehead to make the face stand out more. Having dried the paint, he darkens the background still further and makes the blue jacket brighter.

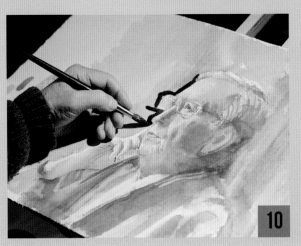

10

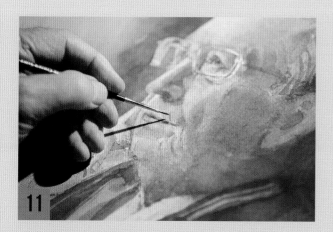

DELINEATING FEATURES

He follows these broad strokes with a fine detailed brush delineating the features again. He's still not convinced about the mouth and enlarges it on the screen to tackle it. He also finds the ears hard: 'They're convoluted aren't they?', 'I can't get the earholes dark enough!' He puts a frown line in and defines the glasses and the lines in the eyes.

ADDING A BLUE WASH

David decides that a blue wash over everything will help: it kills the tone a bit and makes it more realistic. Then, using the hake brush, he adds strong broad strokes of a greeny shade on the background and blues on the clothing.

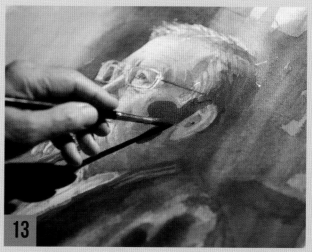

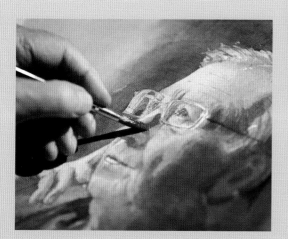

SHADING AND FRAMING

Just before finishing, David decides that the portrait needs more blue. He adds a blue-brown shadow to the side of the face, then strengthens the nose with a reddy brown shade. He also adds more shadow behind the ear and behind the lapel.

FRAMING THE COMPOSITION

David likes landscape formats for portraits and feels that when someone is looking into a space to one side it feels natural to have space on that side, but he decides that this portrait nevertheless needs to be cropped slightly and tries it with a frame, marking where it's natural cut-off points are. After a few finishing touches, he is satisfied that he has finished this painting

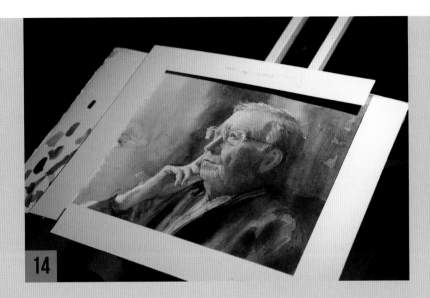

14

'WATERCOLOUR SUITS A CERTAIN TEMPERAMENT, E.G. THE MERCURIAL, BECAUSE IT IS SO QUICK, ONE IS ALWAYS ON THE EDGE OF LOSING CONTROL.'

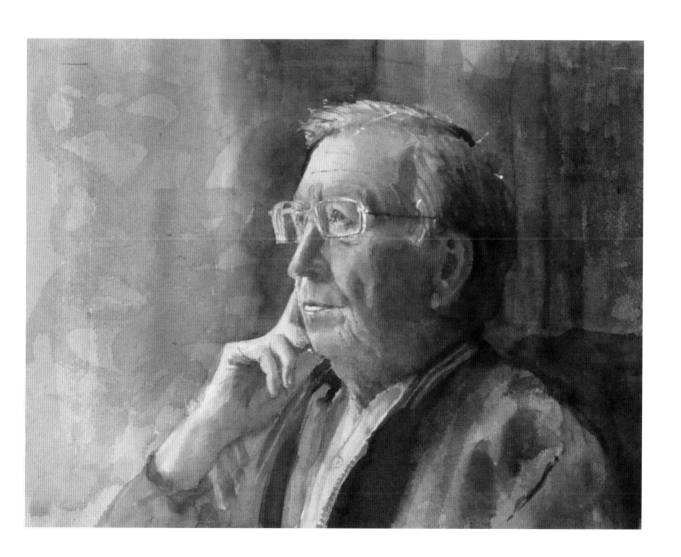

CHRISTIAN HOOK

PAINTS IN OIL AND ACRYLIC

As Christian's work involves the melding of a lot of different skills, it isn't much of a surprise to find out that, having started out studying and working as an illustrator, he then spent some years making prize-winning abstract art before finding his way back to figuration. Throughout the competition, he impressed the judges with not only his compositional sense and his exciting handling of paint but also his ability to get an astonishing likeness. This compelling combination of skills saw him sail through the heats of the 2014 competition and win the final with an ambitious bravura portrait painting of the boxer Amir Kahn for the permanent collection of the Bolton Art Gallery. His prize was a commission to paint the actor Alan Cumming for the National Portrait Gallery of Scotland. As a Gibraltarian, he finds the northern climate and light during winter a bit oppressive so divides his time between his family home and London.

A Good Portrait

Though Christian agrees that likeness is an extremely important component to any portrait, he also suggests that each portrait has to be a representation of the artist too. 'All the portraits I have ever liked or admired are to do with the painter really. There is a point in the portrait when they stop looking at the subject matter and look at what they are doing. As a painter, it becomes about doing your style, interests, strokes, and what you keep and what you lose – all your traits appear on the painting.' He also finds himself drawn to parts of paintings where chaos merges with order. 'That contrast is less to do with visuals or a conscious attempt to do something; it is more of an emotion.'

Although he says he has no preference for one kind of sitter over another, and no subject is easier than another – 'a teacup is just as difficult as the head of a horse or a human' – he does find older people more interesting to paint, because there is more of everything; more contours, more wrinkles, more shadows, more subdued tones, etc. It also becomes a different painting if you know the person, because you subconsciously include things about them whereas, with a stranger, it really is just about the visuals. When working on commissions, he understands that vanity is a trait we all share and believes that making a sitter look good needn't impede his artistic journey in any way.

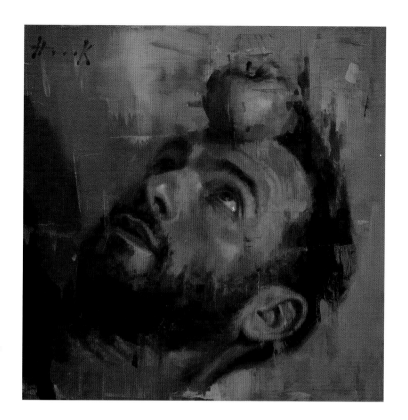

SELF-PORTRAIT
CHRISTIAN HOOK

Influences

He learnt how to deal with shapes, forms and compositional elements from looking at the work of the veteran Spanish abstract artist Francisco Farreras, whose works he compares to found objects or artefacts washed up by the sea. Although he doesn't like Francis Bacon's work, he says he is an influence. 'I don't like the imagery; I wouldn't want to paint like that – but I like the way he investigates trauma and emotion through painting.' He admires Jeremy Lipking's work and the way in which he chooses where to focus, as well as his impressionistic use of colour.

Style and Technique

Christian's work is a balance of figuration and abstraction, which is fascinating to watch as it veers from one to the other in a flurry of colourful brush marks and scraping off until the painting seems to find its own perfect equilibrium. 'I don't have a style – or if I do, it happens without me trying; it comes out of a process of going through chaos and finding things I like and restoring it – that way, my style appears.' In response to the judges' querying his destruction of the image during the course of the painting, he says, 'It is in that process where the art is for me. Otherwise you aren't doing anything. All creativity comes from destruction.'

Having taught in the past, Christian thinks that anyone can learn the basics of drawing, colours and tones and that real creativity is to be found in taking risks. 'How can you discover something in safety? I think it happens with everything in life.'

Not liking to paint onto the plain white surface, he starts with a very loose underpainting in acrylic, which dries quickly, allowing him to get on with painting the next layer in oils. He is generally an impatient painter and uses hairdryers and siccative mediums to speed up the drying time of the paints. Christian prefers working on board because it can take his aggressive painting style without marking, the paint runs more easily and it lets him decide what kind of surface he wants to create, unlike canvas with its ready texture. He only draws in the composition if he is under time pressure; the same goes for gridding the board.

Today's Portrait

Today Christian has chosen to paint his 91-year-old grandmother, Marina, to whom he is very close, not only because she has an interesting face but also because he feels that, as she is familiar, he will be able to tell if the likeness isn't exactly right, which would be harder to spot and take longer to remedy with a stranger. The sitting takes place in Marina's small and busy (with people and ornaments) living room, where he has set up a photobox light to counteract the strong Gibraltar sunlight that streams into the room in places.

He starts by taking some photographs of his grandmother on his DSLR and transfers the best images to his iPad. Usually he works with video and chooses different frames, looking for ones with movement in them. According to where he is in the process, and whether his grandmother has fallen asleep, he alternates between painting from the iPad and from her. He uses Liquitex acrylics for the first phase, which he starts by 'killing' the white of the board with a wash of burnt umber (any mid-tone colour would do really), which he quickly dries with a hairdryer. He then blocks in a very loose and blurry image trying to find a convincing composition in the chaos and hopefully creating some interesting accidents to inspire the next more careful and considered oil-painting phase. 'There is a moment when you think "it" has appeared – it has enough of the order and enough of the other. At that moment it is about the emotion of the paint. In here, she must appear somewhere; slowly she will come out of this mess.'

FOLLOW CHRISTIAN'S TECHNIQUE

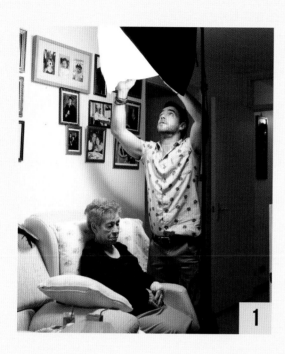

GETTING THE LIGHTING RIGHT

Christian sets up a photobox light to replicate daylight; given the strong sunlight in Gibraltar, where he is painting, this is the only way he can control the lighting. He spends time posing Marina, getting shadows under her nose and eyes. He decides to take the diffuser off so that the light is harsher.

CHRISTIANS'S TOOLKIT

Christian goes through a lot of paint and premixes what he will need in a painting. The palette he uses in his studio is a big glass, which gives him lots of places to mix.

SURFACE Board

PAINTS Acrylics for first layers, then water-based oils

BRUSHES Natural bristle brushes and rounded flat brushes

COLOURS Burnt Umber, Lemon Yellow, Cadmium Yellow, Cadmium Red, Alizarin Crimson, Prussian Blue, Ultramarine Blue, Ivory Black, Titanium White

SIZE 42 x 59cm

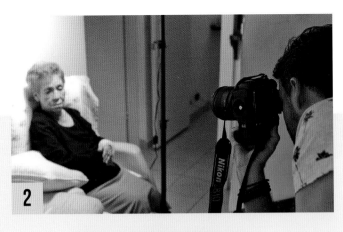

TAKING PHOTOGRAPHS

He takes some photos with a high-end Nikon camera with a good Sigma Arts 85mm and transfers it to the iPad. Having two or three photos to refer to is particularly important today as his elderly grandmother falls asleep every few minutes!

APPLYING THE BASE

The board is already primed. Christian starts by applying a wash of burnt umber, though any colour with mid tone would work just as well. It is easier to get things right on a mid-tone than on black or white, where contrasts are highlighted. He chooses to use acrylics for underpainting because oils take too long to dry. He spreads this base with water and tissue and an adherent that dries the acrylic, then uses a hairdryer to speed things up even more, so that the board is ready for the next stage in a couple of minutes.

THE FIRST LAYER

Christian's plan is to cover the board with acrylic paint and create a blurred image of Marina. Then he can start picking and choosing. The sitter doesn't really feature properly in this layer. It's not an abstract painting as such, but Christian is trying to find something exciting, something unexpected, a mistake – 'I'm always waiting for something bad (but good) to happen'. He begins by putting a white line at the top and a blue-grey background over the brown wash.

BLOCKING IN THE SHAPES

He then starts blocking out the black shape of her outfit, before her head. 'I just put whatever I see – it probably won't stay there, will move around. I keep what I want, change what I don't, then I'll decide after that. I haven't started painting until the whole board is covered.' Until it's all there, he can't decide what he wants to do. 'Sometimes the way I don't finish things gives me a line to move things', he explains. At this stage he is looking at his grandmother; later he will use the iPad.

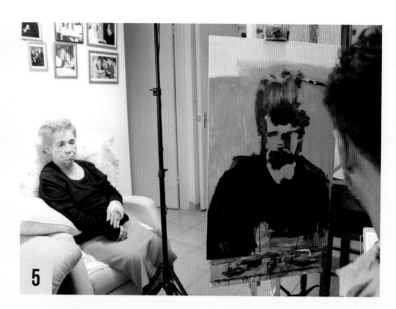

5

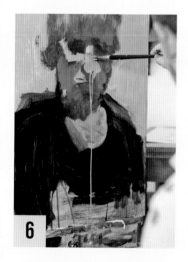

6

PLOTTING IN SHADOWS

He plots in the major shadows in black then various greys. He then rubs across it, making it vague, and starts doing shadows of her face again. He is still deciding where he wants it, trying to work out what his grandmother's relationship is to the canvas and what will be around her, deciding if he likes it.

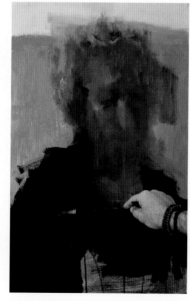

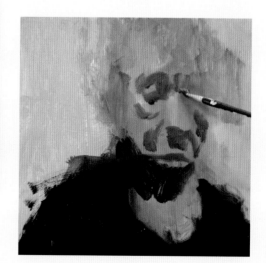

THE PORTRAITS

81

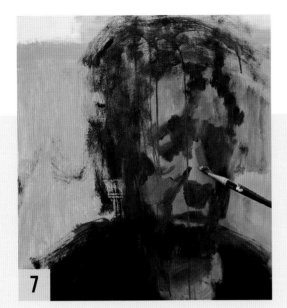

ADDING COLOUR SHAPES

Some brown goes on, then a greeny tone. Christian is basically blocking off colour shapes. He adds a mustard tone, then a lighter one, but colour still doesn't matter. At the moment, it's about emotion; he's not looking to see the finished thing but wants to create a tension with direction. 'This is where I see mistakes I want to keep. One more layer of chaos and then look a bit more.'

PLAYING WITH THE ANGLE

Christian decides that the ear is the only thing he's seen that he likes and that he is going to paint the head again somewhere else and play with the angle a little bit. The colours are translucent at the moment, so you can see the background; this next layer will be thicker, with more consistency. He puts in vertical lines to create direction.

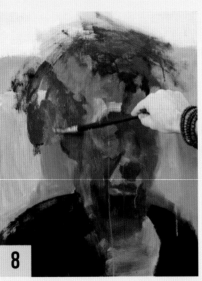

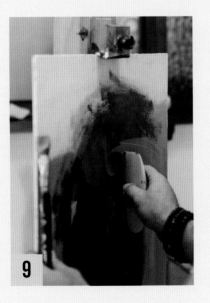

ADDING TEXTURE

Having added a bright light blue straight out of the tube, he uses a rubber or piece of cardboard to give texture and lines. Although Marina has now practically disappeared from the board, he's a lot happier. 'It's like playing', he says, 'When you're a child, you don't think of anything, you just play… I try and have a play with the canvas or board first.'

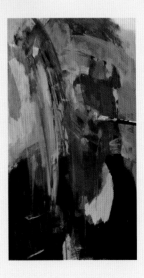

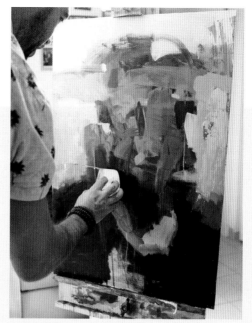

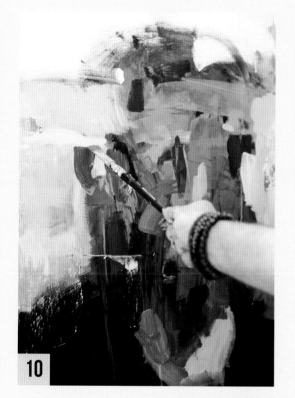

10

FINISHING THE FIRST STAGE

He adds a bit of red to the ear then gets the hairdryer out again. It's the end of the morning and the end of his acrylic painting: after lunch he'll switch to oils. The portrait is fragmented and blurred at this stage – somewhat redolent of Francis Bacon.

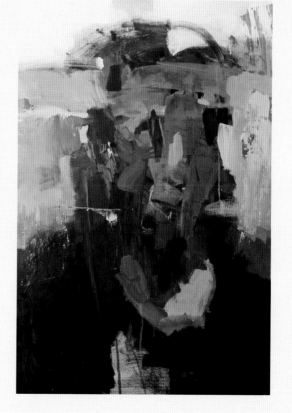

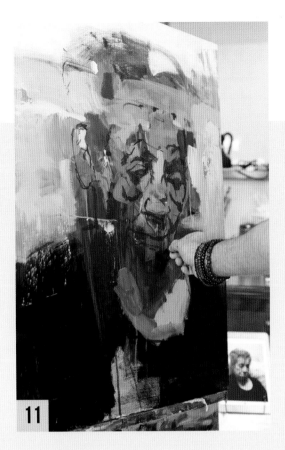

11

DELINEATING THE FACE

Before beginning with the oils, Christian sketches on the portrait with charcoal, delineating Marina's face. He has moved the face down in order to keep the rough top of the head and the white line across the top, which he likes.

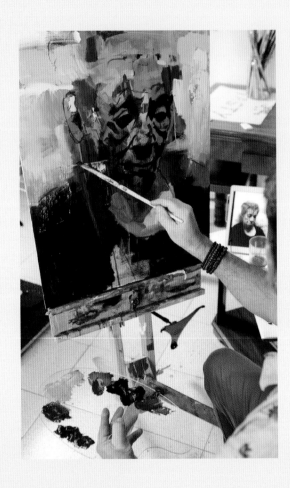

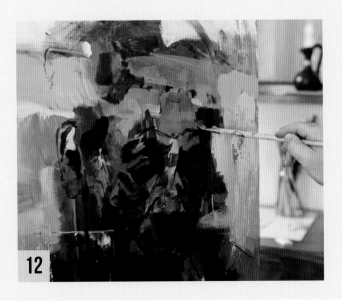

12

SCULPTING THE FACE

'Now it's the fun bit!' Oils are Christian's favourite part, where he gets to choose what he will concentrate on. 'This is the more ordered part of the painting', he explains, 'I've had my chaos bit; now I work a bit more carefully'. Here, he is sculpting the face and colour is still not relevant. He uses a more subdued palette and just one brush at this stage.



THE PORTRAITS

84

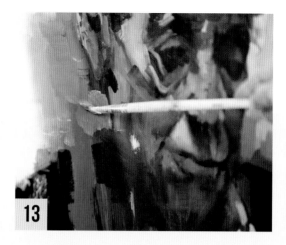

13

BRINGING IN THE HIGHLIGHTS

The first layer in oils completed, Christian checks which areas need simplifying and which he wants to keep complex. There are very subtle variations in colour. The iPad is fine for now, but he'll want to have the sitter again for the skin colour. He uses a bit of turps to soften the painting and works to bring in the highlights.

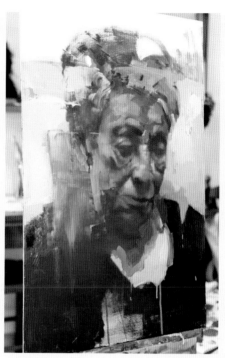

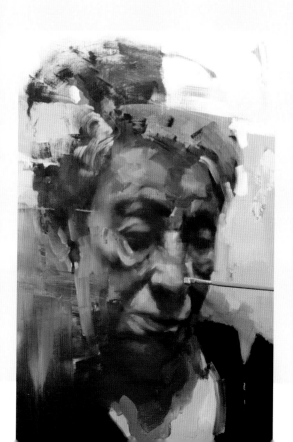

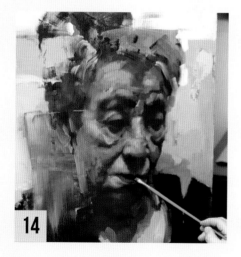

14

ACCENTUATING FEATURES

Christian is satisfied with the shadows and dark areas but still needs to add mid tones and highlights to bring out areas of the face. He thinks the rest of his grandmother's face is far more interesting than her eyes, so concentrates more on her lips, forehead and nose.

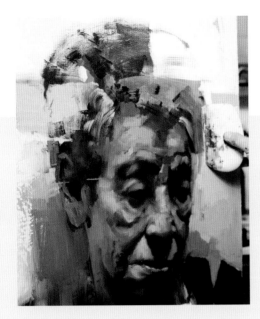

ADDING SOFTNESS AND COLOUR

He works round the edges to get some softness. At the moment, there are too many little strokes everywhere, he feels, so he creates some flat areas with broad shapes that will bring out the important features of the face. At this final stage, it's about adding the colours he really likes and that work tonally: he chooses greens (but only a particular set of greeny-greys), turquoise, blues and purples. The painting is finished. Although he feels that he could have left it a while ago, the final touches have improved it.

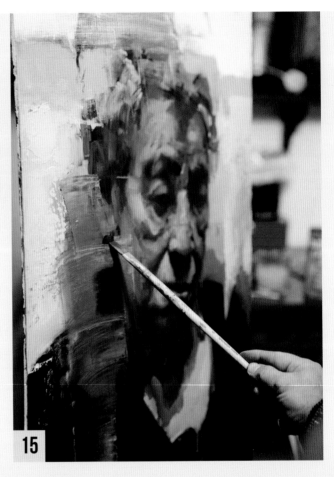

15

'HOW CAN YOU DISCOVER SOMETHING IN SAFETY?
I THINK IT HAPPENS WITH EVERYTHING IN LIFE.'

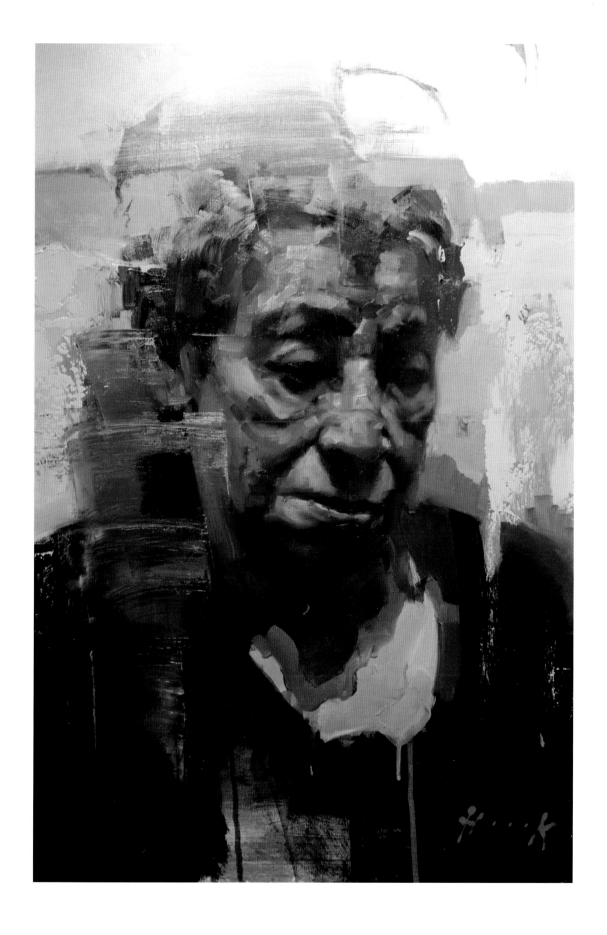

ALAN McGOWAN

PAINTS IN OIL

Alan studied illustration at Edinburgh College of Art where, he says, skills weren't taught after the first year but where he did meet lots of unusual, creative and intelligent people with whom he could discuss and exchange ideas. He and his fellow students were encouraged to learn by observing how others approached creative problems: 'You become a sponge amongst other sponges, all absorbing'. He participated in both years of the Sky competition, entering with self-portraits of painterly vitality that showed off his unique technique of blending abstract mark-making using materials as diverse as oil bars, oil pastels, beeswax, chinagraph and oil paint while capturing the human form with great vigour. After winning his heat in Edinburgh in 2014 with a superb portrait of Julian Fellowes, he proceeded to the semi-finals at the Royal Academy in London.

A Good Portrait

'Paintings of people are just compelling. I always find them the most interesting subject for me and that's why I produce them. People are the most interesting things I know.' For portraits, unlike his other figurative work, likeness is fundamental, but he states that a work is also a portrait of the period of time he has been painting the portrait: 'On a different day, at a different time, it would be a different painting'. He is also not interested in what the sitter might be thinking – the psychological aspect means nothing to him; he is very much reacting emotionally to what is there and what is happening in front of him. Sometimes the vitality of the painting can take over from the likeness – it can become a successful painting but not a successful portrait, in which case, 'do another one!' If a portrait has been commissioned, one can feel under pressure to please the subject, which is why Alan doesn't do them much; he prefers the freedom to create his own images. When painting portraits, he doesn't really have any preference in terms of sitters. His aggressive and vigorous brushwork might work less well with a softer, rounder complexion, he adds, but then he doubts that any of the people he paints expect to be flattered.

Influences

Although he likes expressionistic abstract painting, it interests him only to a degree. What appeals to him is the medium as it is tied to the subject – one abstract, one representational, so a line is a line but also a hand. So he favours artists whose work displays a tension between representation and abstraction that makes the images exciting, for example Schiele, Rembrandt, Rubens, Francis Bacon, Lucien Freud, Jenny Saville and Alex Kanevsky – all representational artists. 'I don't see art in historical terms; you can see a

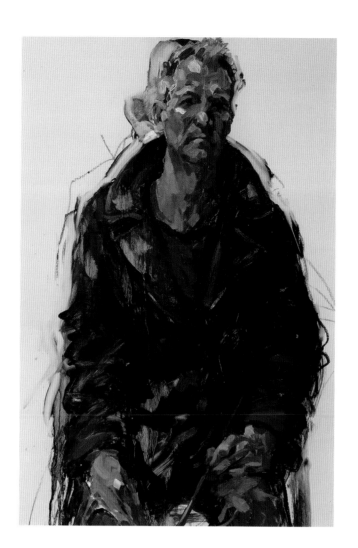

SELF-PORTRAIT
ALAN
M^CGOWAN

500-year-old painting, a Rembrandt, and still see the brush marks look as though they went down yesterday, and I would look at a Rubens the same way as a Saville, how the paint runs…'

Style and Technique

For Alan, the painting language an artist uses comes from who they are: if they are authentic with their work, then it will be expressed in their art. If the artist is someone who is very certain, for example, this will be visible in the attitude behind their brush marks. Alan uses lines to describe form as well as tone when he paints because he likes their gestural energy and mobility, and he chooses to include them early on. They are part of a visual language that incorporates the dynamics of opposites such as opacity and transparency, thick paint and runny paint, earth colours and saturated colours, etc.

His current looser technique has evolved over the last ten years, during which time he has worked in lots of life classes and used coloured crayons to capture the image quickly. He doesn't want a closed and settled image, like a Victorian

painting, say, so the paint might suggest one thing that the drawing will confirm or at other times contradict, creating a more ambiguous image. Just as parts of his paintings are easy to read and other parts left more unformed, so his line moves about, exploring the subject rather than stating 'this is fact'. 'Because I find it more exciting, not because I can't do the other thing. These paintings aren't about saying what something is, they are paintings about someone looking for something.' The blue Alan applies as a ground to work on is an updated version of the Renaissance use of *terre-verte* as an underpainting for flesh tones; it is contemporary and unusual but derived from a classical tradition, as is his use of glazing, which he has adapted to his own needs.

Today's Portrait

The sitter is Will Pickvance, a musician and entertainer whom Alan has known for a number of years, and the sitting will take place in Will's studio at Summerhall in Edinburgh. Alan thought it would be an interesting challenge to capture a musician at play, a moving subject, but took the precaution of preparing for today's portrait sitting by doing some preliminary sketches in paint and charcoal to work out the pose and set up. Preparation is important to Alan, and he often spends more time on preparation than on the final portrait– akin to an actor rehearsing for a play. As he says, 'All this means is that when I get started on the painting, I am not only reacting to what's happening, but also have a memory and knowledge and analysis of what's going on'. As Will's piano takes up most of the space, Alan has set up the easel close by one window, which doesn't give him room to step back, but just enough space to lean back to get an overview. As Will is silhouetted by the opposite window, Alan has placed a light on the piano to illuminate him. Being side on, above and looking down means he can get Will's head and his hands on the keyboard, which is where the action is, in focus.

Alan prefers painting on board rather than canvas as he likes the hard resistant surface and the way the paint runs and moves on it, and he has primed today's board with a mid-tone blue acrylic and shellac. His brushes are long, flat hog-hair ones and the palette he is using today is a large primed board. The colours he uses are as follows: Prussian Blue, Paynes Grey, Manganese Blue, Raw Umber, Raw Sienna, Yellow Ochre, Vermillion, Alizarin Crimson, Indian Red, Mars Violet Deep, Burnt Sienna, Magenta, Titanium White and Ultramarine. His glaze medium is made of linseed oil and Dammar varnish and his drawing implements include oil bars, oil pastels and a white chinagraph pencil. Throughout the day, Will matches Alan's painterly improvisations with his own medley of jazz standards, some Neil Young, Irish folk tunes and a bit of Tom Waits.

FOLLOW ALAN'S TECHNIQUE

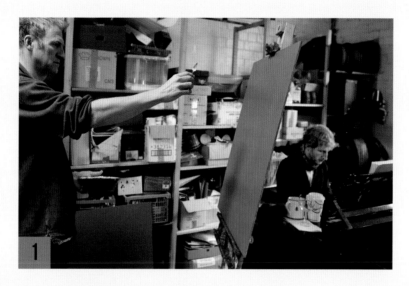

MEASURING DISTANCES

Alan stands throughout, a big physical presence, without room to step back but tall enough to lean the top half of his body backwards a fair bit throughout the process in order to gauge the portrait from some distance and see if it's working. A lot of squinting goes on as he measures out distances using his hand with the middle finger pointed out.

ALAN'S TOOLKIT

Alan paints on board not canvas. He likes a hard, fast surface, so paint will run and move properly. It is primed with acrylic and shellac and has a tonal ground on it, as opposed to white, which will show.

SURFACE Board primed with mid-tone blue acrylic and shellac

PAINTS Oils, plus oil bars and oil pastels, white chinagraph

BRUSHES Long, flat hog-hair

COLOURS Prussian Blue, Paynes Grey, Manganese Blue, Raw Umber, Raw Sienna, Yellow Ochre, Vermillion, Alizarin Crimson, Indian Red, Mars Violet Deep, Burnt Sienna, Magenta, Ultramarine, Titanium White

SIZE 77 x 63cm

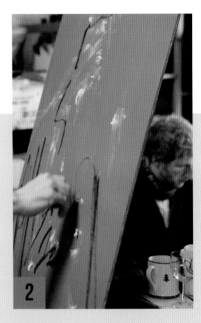

MARKING THE SHAPES

He applies beeswax (the white gunk visible in the photograph above) to sketch roughly where the subject will be. This is followed by black oil bars to give Will and the piano a presence. It doesn't need to be in the 'right place' – in fact, it's better if not. The beeswax and oil bar create a surface that Alan will work into. They make it much more difficult, more slippery, but more receptive to the looseness he wants to capture.

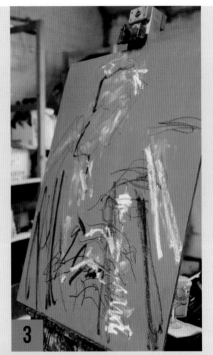

APPLYING OIL PASTELS

Now Alan starts to put on oil pastels – white, yellow ochre, very subtle green, etc. Again, it doesn't matter where as long as it's there – he would miss them if they weren't. Had he chosen canvas as his surface, he would be making dents at this point, hence his preference for board, which gives more resistance, allowing him to vary the marks he makes. He adds more black oil bar for the shadows and also to shuffle the position.

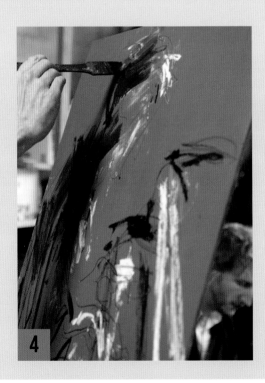

PAINTING ON THE GLAZE

Next, Alan applies a putrid, grimy glaze of linseed oil and dammar varnish mixed with transparent paints, following Will's shape and part of the piano. He has to make up the glaze twice as the first lot is too dirty and there's too much white. It needs to be transparent: if it is too tinted, the colours Alan will subsequently add won't make enough of an impact on the painting.

CREATING SCULPTURAL FORM

This glaze is there to create a massive sculptural form. Again, it's not well-drawn or placed – the manipulation of the image will come later. The glaze is an interactive surface that runs and drips, and the brushstrokes are active in it. It's creating a surface that Alan has to react to and it's difficult to work with, but Alan likes that challenge. With this technique he can't go back, but being too careful would restrict the freedom of what he does. He has to be confident with his mark makings.

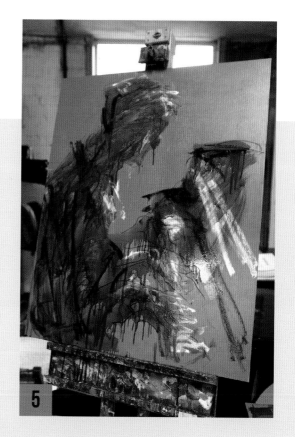

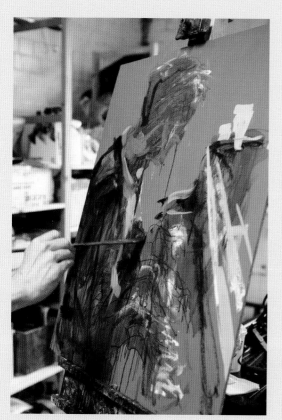

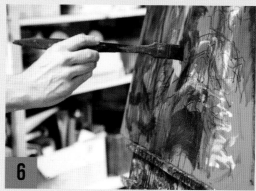

FIRST BRUSH STROKES

Using the same brush, he paints a warm grey/taupe over the piano area then a dirty lilac over the face and a near black for the jacket, mid-browns on the face then dark purples. At this point, Alan is looking to find the tones and shapes, the image that is in there somewhere. Colours can be adjusted later. He puts beiges onto Will's face for highlights then applies white chinagraph around the face and hair.

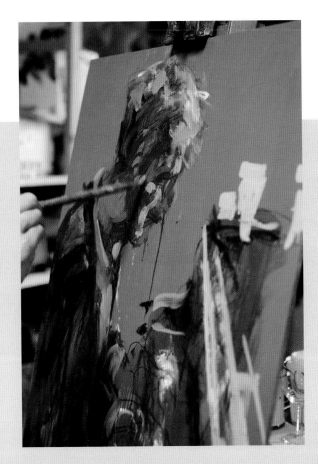

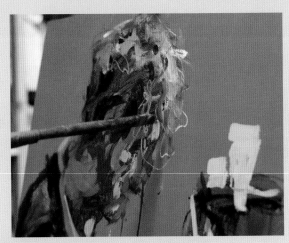

TRANSPARENT TO OPAQUE

At this stage, most of the paints are transparent, some of the highlights slightly opaque. Alan will move towards the opaque when trying to resolve the actual portrait but he is still searching for the forms, so doesn't yet want to be too certain about what goes where. Opaque paints commit him. Working out relationships – hand and head, angles of head changes, hands moving up and down – is difficult. It's not straightforward to get the architecture of it.

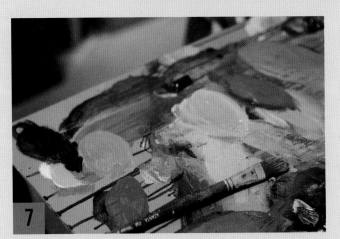

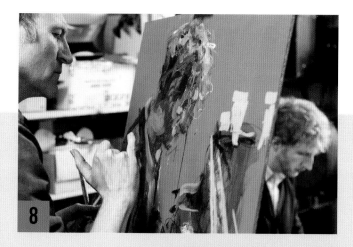

8

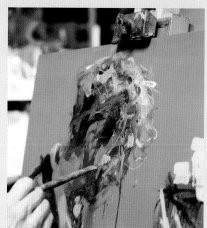

CREATING DYNAMICS

Alan thinks about how the painting will evolve. He doesn't want to bring everything to resolution where it is static but rather to create movement, so there might be two or three edges of things, such as the nose, for example – but not two or three of everything! The ear can be established as a still point on the head; other areas will be suggested rather than firmly delineated. He is looking for the dynamic balance between opacity and transparency, defined and indefinite, things that are placed and those that are hinted at. Line is good for this, at suggesting things: you can see the line but you can also see through and underneath it.

PAINTING THE HANDS...

Alan has put three hands, which he likes. He wants them at different levels, not all fully painted, not all half painted, so needs to decide which will be the most and least solid. He thinks about it a lot and comes up with a 'best guess': 'My experience says to me that having them all with the same weight won't have the dynamism I want, that you have to emphasise some things over others to have a rhythm in the painting. But of course it might not do that, and if it doesn't work you have to react instinctively.'

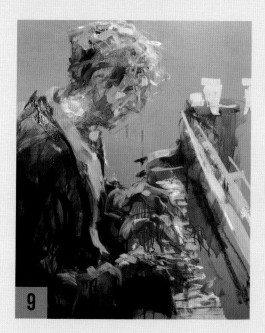

9

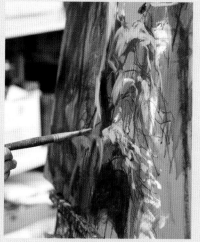

... AND THE PIANO

While he is painting the hands, Alan gets Will to play slower to make sure that what he is painting makes sense on the keyboard and is correct musically in terms of the placement of the knuckles, hand etc. He dabs paint off the keyboard when it's too bright, that black-and-white contrast being in danger of overpowering the painting. He then covers the ivories of the piano with a dark glaze.

KNOWING WHEN TO STOP

In most situations, Alan says, he would do more work – perhaps a series of paintings, taken to different levels and interesting in different ways – but today he feels in danger of tightening things up, closing the forms and losing the movement in the picture. He decides it's time to get out: 'I don't want to lose the sense of the event by working too long.'

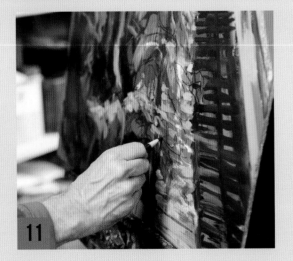

'ON A DIFFERENT DAY, AT A DIFFERENT TIME, IT WOULD BE A DIFFERENT PAINTING.'

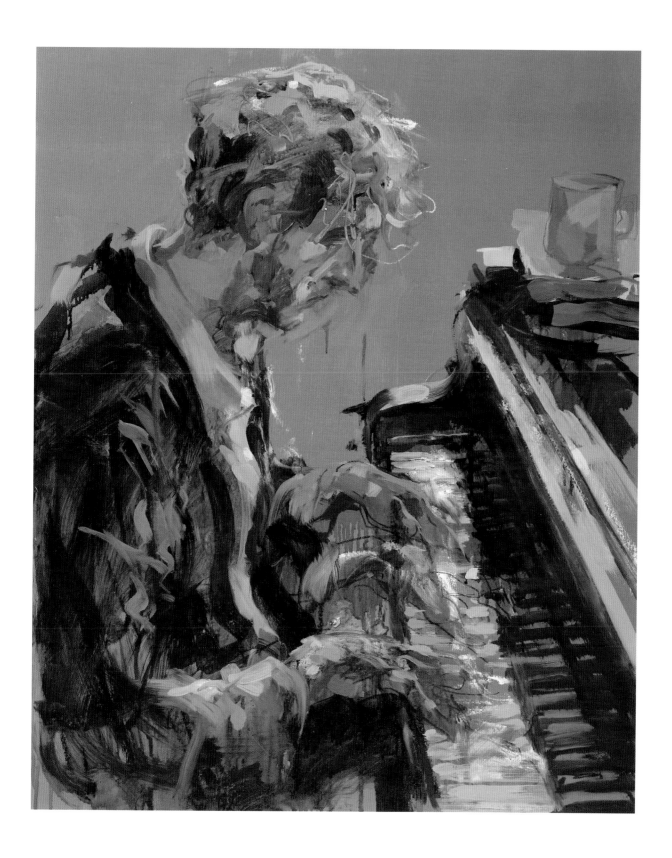

BILL BONE

PAINTS IN OIL

Bill considers himself self-taught, having started to paint in his bedroom at his parent's house in the USA while picking up tips from artist and TV personality Bob Ross. He later studied Fine Art at the University of Wales, specialising in painting, but found that he wasn't taught much in the way of technique there. His use of wax and pointillist marks in his beautiful, contemplative self-portrait intrigued the judges and, after winning his heat in Cardiff, he went on to paint a wonderful double portrait of Richard Dawkins and Sally Hitchiner at the semi-final at the Royal Academy in London.

A Good Portrait

For Bill, a combination of a likeness and an interesting painting makes a good portrait. The proportions need to be correct so that the portrait looks like the sitter, without the distraction of a nose being in the wrong place, but it should be clear that it is a painting as well. The angle of the face is important: the sitter shouldn't engage with the viewer face on but should be looking slightly up or down and be immersed in their self-contained world. For Bill, the mouth is the most important feature and can totally define the likeness – or lack of, as the case may be. As a portraitist, he prefers painting old men: he has a wish list, of which one was Richard Dawkins; Len Goodman from *Strictly Come Dancing* is another; as is Dom, from *Gogglebox*. He admits it is the lack of make-up and the colours in the skin that make them more interesting subject matter.

Influences

When Bill started out, he really loved the illustrative realism of Norman Rockwell and the stories his pictures were able to tell but says Rockwell is no longer a strong influence for him. These days, he prefers artists whose works capture the balance of exactness and painterliness he admires in portraiture, such as Jonathan Yeo and Colin Davidson. His work incorporates a technique that looks as though it is related to traditional Pointillism but in fact came about when he observed the pixels created when he blew up images on his first scanner. He then tried to recreate this effect when painting skin, so though it seemed like one colour from a distance it was actually made up of many strongly coloured dots of paint.

Style and Technique

Bill's work is an interesting hybrid of precise, technology-aided drawing and a lumpy, painterly application that comes from brushing the main tones and colours onto the wax ground, which he then augments with brighter touches in his pointillist method. He first takes a photograph of the subject in natural daylight on

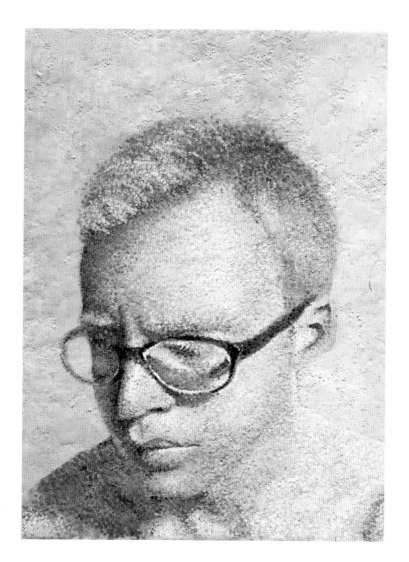

SELF-PORTRAIT
BILL BONE

which he then works in Photoshop, adjusting the colours so they are as natural as possible and adapts the background if he so chooses. The corrected photo is his sole reference for the painting, as he showed during the competition, when he focused only on the image of the sitter on his iPad. He also introduces a grid to the image, to match the 2cm² grid he has drawn onto the canvas he is going to use. He says he never really has a problem with capturing likeness because the proportions are easily transferred from the photo to the canvas using his grid technique.

His use of wax as a surface to paint onto originated from seeing his father wax his skis when he was a child and has evolved over time. He heats the wax using an iron and allows it to drip onto the canvas from a height. He doesn't like acrylic and, although he has experimented a bit with watercolour, he feels most comfortable using oil paints; they are what the old masters used. When he was at school, pupils weren't allowed to use oil paints, so using them out of hours felt quite rebellious at the time. Bill doesn't use any medium and, unlike other artists, finds he ends up using one brush for the whole painting. 'I like the colours I used previously to be

on the brush because colours aren't just red, orange, and pink, they have blue and green and it helps keep the colours interesting when those colours are included in the mark rather than just the pure colour. It also makes it consistent, so if I go into an area with a completely different colour, it still has this colour in it somewhere.'

Bill's way of painting is very methodical. After he has drawn in some thin outlines in brown paint, he will work on one tiny piece of the face until it is finished before moving on to the next, always concentrating on the specific rather than the whole. When the one layer is down and correct, he will tweak it with a second layer of more extreme colours to pep it up a bit. He finds his approach meditative and enjoys being immersed in the minutiae of the painting.

Today's Portrait

As Bill doesn't paint for a living, today's portrait will be made in his house, which also dictates the size, as he doesn't have space to store large paintings. The sitter is 25-year-old Josh Coles-Riley. He has sat for a portrait before but not for Bill. 'I know his face, so that makes it easy, but it's also weird at the same time. I've never painted him before. His hair will be a challenge; I hate hair! It's the detail in there; the hair needs to be as realistic as the rest of it, but the amount of detail compared to, say, broader areas of colour such as the cheek...!'

He uses a mixture of different paint brands. His palette includes Titanium White, Naples Yellow, Cadmium Orange Hue, Grumbacher Red, Alizarin Crimson, Dioxazine Purple, Cobalt Blue, Sap Green and Burnt Umber, though he uses more colours than he has on his palette at any one time. He mixes purple, blue, crimson and brown if he needs a black. He uses a synthetic brush, with a rounded tip, size 4. As he goes back over an area, he will try to add as many colours as he can, though this might not be obvious later when viewing the picture.

FOLLOW BILL'S TECHNIQUE

WORKING IN PHOTOSHOP

Bill has imported the photo he's taken of his subject into Photoshop and starts today by creating a grid over the image. He then works on the white balance and on getting a colour in the background of his choosing. He may not stick to that background when painting – it's just a starting point – but he does try and use photo colours within the face.

BILL'S TOOLKIT

Bill feels most comfortable using oil paints – and uses one brush for the whole painting.

SURFACE Waxed canvas (pre-gridded)

PAINTS Oils

BRUSHES Synthetic no 4, round tipped

COLOURS Titanium White, Naples Yellow, Cadmium Orange Hue, Grumbacher Red, Alizarin Crimson, Dioxazine Purple, Cobalt Blue, Sap Green, Burnt Umber

SIZE 55 x 45cm

2

WAXING THE CANVAS

Bill has already drawn a 2cm² grid on the canvas he is going to use. He now heats an iron and melts a block of beeswax over the gridded canvas from quite a height so it splashes onto the surface in smallish drips. He likes the surface to be evenly covered but fairly rough and varied, which is difficult to control as the wax is transparent when hot. He leaves some areas bare to vary the texture more.

3

GETTING A FEEL FOR COLOURS

Bill begins by painting the lips, which he likes to get done first then work his way up the face. His palette contains the base colours he tends to use, but once he begins painting, he will probably find he uses only half of them. It takes him a bit of time to get a feel for the colour, but starting off with the lips helps. If he were to start with a cheek, for example, by the time he moved to the other cheek the colours might be different and wrong.

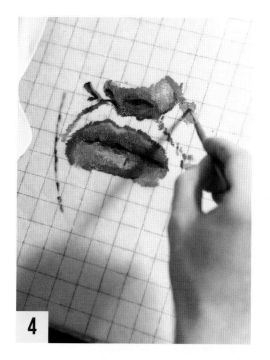

4

FOCUSING IN

Next comes the nose. Bill's approach is very different to that of many of the other artists in this book in that he doesn't react to what occurs to another side of the canvas with paintmarks elsewhere. He paints meticulously, concentrating on one feature or tiny area of the portrait at a time. Because he is focusing on a single 2cm²-grid square, he doesn't have to worry about the bigger picture.

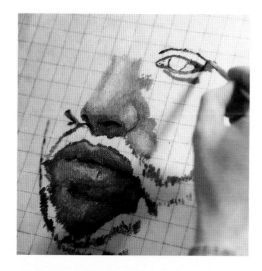

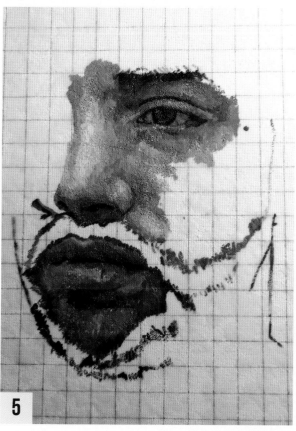

5

STRIVING FOR CONTRAST

The physicality of the painting – that 3D effect – is beginning to come together, but Bill is struggling because the shadows are not as contrasting as he would like them to be due to the lighting in the photograph. This means that the skin tones are quite similar and don't model as well. Another problem he is encountering is that the texture of the wax is more uniform than usual.

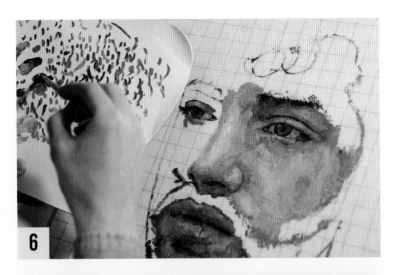

6

PERFECTING SKIN TONES

With the second coat of paint, Bill is able to match the colours, so that a particular area of skin tone matches that on the other side of the face. By the time he has done one layer, he can go over with another layer and play a bit more, picking out the cooler, more extreme colours in the skin tone and adding those in a subtle way. It's fun and he feels really in the flow, adding colours in this way.

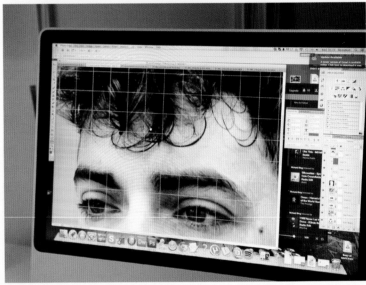

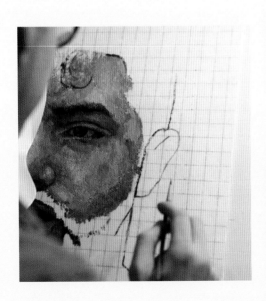

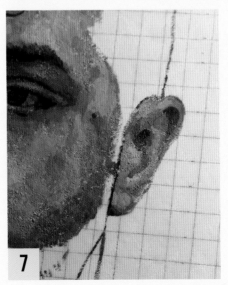

7

PAINTING THE EARS

Bill doesn't like doing ears: there are so many lines, and more colour variations and lights and darks than anywhere else. It can end up looking either photorealistic or amateurish. You have to be so precise, and it's so time consuming for such a small part.

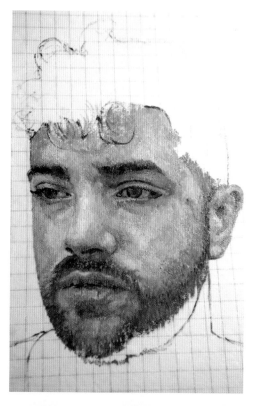

ADDING THE BACKGROUND

Having decided to use today as a chance to experiment, Bill is going to create a wash in the background. It's an effect he likes in other people's work and he wants to see if he can make it work in his.

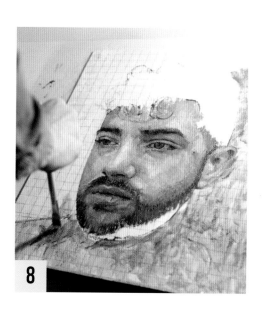

8

He normally doesn't use anything to mix his oil with because he paints with such minute strokes, but here he's created a wash with turps. He's using the same colours as on the face to keep it consistent, so it flows as a painting but he doesn't intend for it to look as finished as the face and wants the grid to show through, for the viewer to be able to see how the portrait was created.

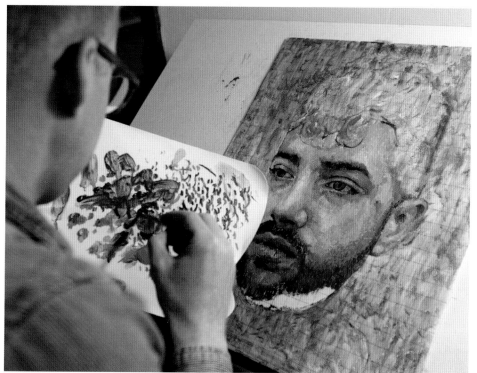

DEALING WITH THE HAIR

Though it was scary, Bill felt liberated by what he was doing with the background and by making what were, for him at least, broad brushstrokes. But now he has to turn his attention to the hair – and he's dreading it, particularly with all those curls. (The beard is fine: he's abandoned his usual pointillism technique, in favour of brushstrokes.) He usually likes to work in layers, so on a normal day he would actually paint the skin underneath first and then add the hair on top, but today he's under a time constraint. He struggles with the hair, trying to create too dark a presence. He lifts some paint off, which improves it, then applies a few strokes on top.

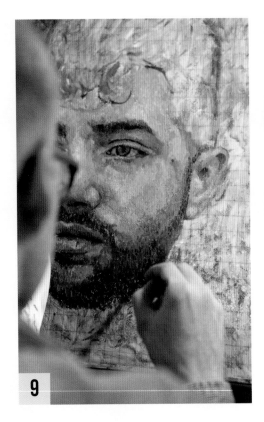

9

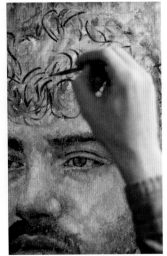

FINISHING UP

He knows when he's finished a portrait when whatever he's working on no longer adds any significant value to the painting. But also, because he works on one specific area at a time, he can in theory leave it when complete: it's easier for him to tell when he's done than it might be for other artists who work differently. Normally, he would do the hair, add bits and generally tidy up the portrait the following day.

HIS PALETTE INCLUDES TITANIUM WHITE, NAPLES YELLOW, CADMIUM ORANGE HUE, GRUMBACHER RED, ALIZARIN CRIMSON, DIOXAZINE PURPLE, COBALT BLUE, SAP GREEN AND BURNT UMBER.

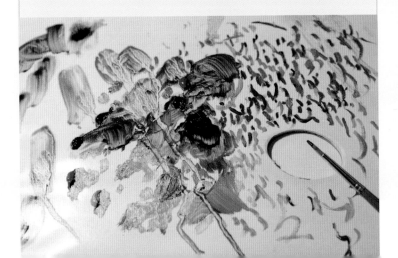

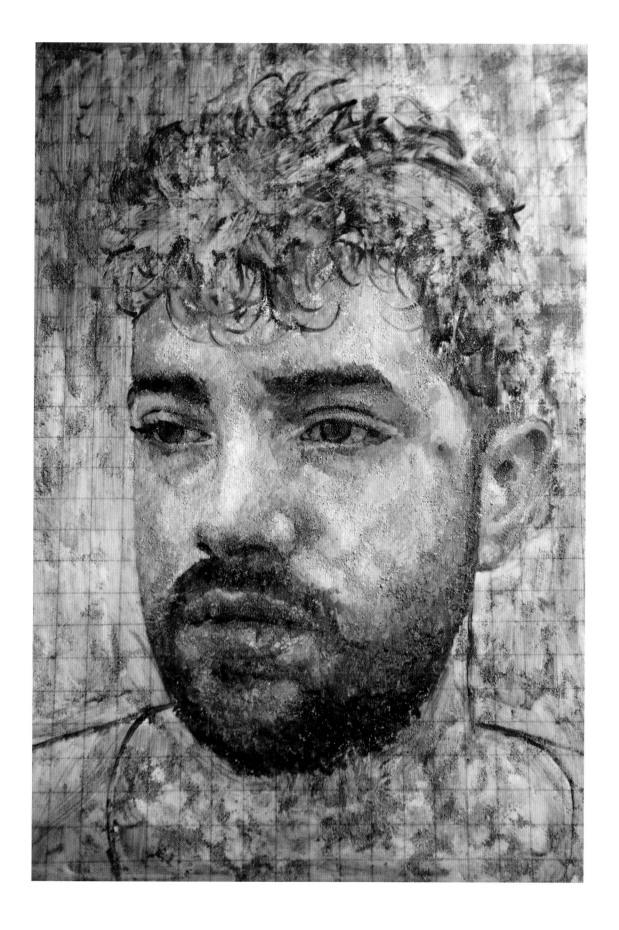

LUIS MORRIS

PAINTS IN OIL

As a designer, Luis Morris's early work used to be photographic in style, but then he took time out and went to art school – Heatherleys in his case – where he was introduced to a less illustrative, more painterly, colour-based approach to figure painting. When he took part in the competition, he was juggling painting with his job as a banknote designer. He entered with a luminous self-portrait and went on to win his London heat with an extraordinary double portrait of Juliet Stevenson and her son in which, unlike any of the other artists in the competition, he had attempted to capture the whole scene before him by assembling it out of mosaic-like dabs of the purest colour. He proceeded to the final with a beautifully inventive commission for the Royal Ballet School of Lauren Cuthbertson.

A Good Portrait

Luis doesn't really talk about looking at portraits by other people, but he does have some interesting views on the effect of portraiture on the artist and the sitter: '…celebrating a person's uniqueness, that's the fun of it. You can go to London and walk through the streets and people are coming at you, like ants, just a barrage of faces, or even on the tube, and it's uncomfortable. You can take any of these people and isolate them and paint any of them and celebrate them, and they become special. They become the most important person in the world at that moment; that's what portraiture does'.

In that sense, he sees flattery and sentimentality as the enemy of portraiture because they normalise people, changing things that make them who they are. As an artist, one needs to be truthful and paint the portrait as though no one else is going to see it. Although he says he just tries to faithfully record what is in front of him, the psychology of the sitter does soak into the painting, so getting some interaction with the sitter is important: it affects his decisions about what to exclude and what to keep in. 'Different colours give you different emotional charges and you will be trying to crack a code, working out why they are making you feel a certain way. If you don't know the person and can't get to know them, for example, in a competition, your prejudices, rightly or wrongly, give rise to a different kind of painting'. He also says he likes painting portraits because it forces him to look at people for longer than he normally would be able to and to contemplate them. It's not a way of expressing an idea he has already; rather, it's forcing him to have ideas.

Influences

Luis talks a lot about the immediacy of the moment during a sitting and reacting to that. He doesn't like to pigeonhole his work solely to the Euston Road tradition,

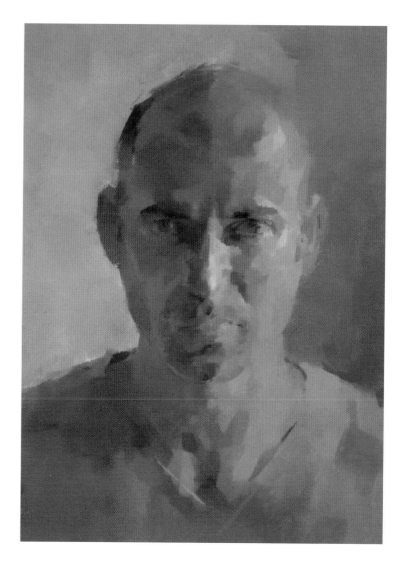

SELF-PORTRAIT
LUIS MORRIS

especially to the work of Euan Uglow, though he does admit that the tutors he studied under at Heatherleys come out of that tradition and their approach to colour and tone is informed by it.

Style and Technique

Undoubtedly, it is Luis' use of colour that defines him, as well as his objective and impartial approach to the whole scene in front of him. After he has decided on the right size of canvas and set up, he will fix and transfer measurements, either as a drawn mark or as a patch of colour, on to the canvas exactly as they appear to him on a one-to-one scale from the same vantage point throughout the day, using what is referred to as the sight-size method.

He likes his colours to be as pure as possible without being garish or unrealistic, and his main concern is to get the colour balance of the painting right. Just as a photograph might be either muted or supersaturated, so the artist has to find the correct colour key for the painting, so all the elements work together.

Luis prefers canvas for its texture; he feels it has a rhythm of its own and when you drag your brush across it, it shows up and feels nicer to work on than board, where the paint slides around on top. He starts quite thin and likes to paint over the top with thicker marks once the bottom layer has dried slightly.

His style combines dynamic lines to place the sitter and flat patches of colour. He puts colours in roughly where they are and then contracts or expands them. 'In this way you define an edge of a colour by another colour, so you're not just filling things in. This way, the drawing and the painting happen at the same time.' Luis likes to finish a portrait in one sitting because he feels that when he comes back to a painting, he's lost what he had; he's intruding on something he can't quite get back.

Today's Portrait

Luis has decided to paint his mother, Rafaela, in her armchair at home. Although this precludes the natural daylight he usually prefers to paint with, he considers it's worth it because painting people in their natural environment tells us more about them. He has painted his mother from photos and done a few drawings of her but never painted her from life. Unlike a lot of portraitists, who say painting someone you know is easier, Luis believes that painting even a familiar sitter can be tricky – even just working out exactly what it is that is familiar about their face. For him, knowing the sitter is more a motivator than a matter of ease. He is very close to his mother and there is an added poignancy to painting her now she is 83 (she will sleep through most of the sitting). 'I thought I knew my mum's face very well, but it's changed a lot in the last few years. It's kind of shocking to me because I've known my mother as a certain person, a strong person. I'm reconnecting with what my mum looks like now, making sense of it.'

After a quick charcoal sketch to get his eye in and to get an idea of the composition, he chooses a 51 x 76cm canvas, which is big enough to incorporate the whole scene but, more importantly, large enough for a good-sized portrait head within it too. His mother is flanked by two toy dogs she likes, but Luis is uncertain about whether he will include them because the diagonal composition is counterbalanced rather well by her walking stick. What preoccupies him most is that he is looking down at Rafaela, which makes her look small and gives the portrait a vulnerable feeling.

Luis' palette is comparatively simple: it includes Titanium White, Viridian, Ultramarine, Alizarin Crimson, Cadmium Red, Cadmium Yellow and Lemon Yellow. He doesn't touch the canvas for a while because he starts by mixing most of the colours he can see in the scene in front of him on his palette with a palette knife to work out the relationships; these will be augmented as the day goes on, as and when he needs to adjust. He tries to use the biggest brush he can for any given situation; he prefers short, flat acrylic brushes because they have a precise edge. There is some music in the background as Luis likes to listen and paint or talk and paint; it sometimes helps to distract the conscious part of the brain and let the subconscious part do the painting.

FOLLOW LUIS'S TECHNIQUE

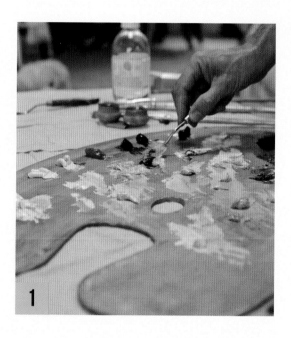

MIXING COLOURS

Starting with a simple palette of white plus just six colours – a green, a blue, two reds and two yellows – Luis mixes most of the colours he can spot in the *mise-en-scene* on the palette before touching the canvas. A lot of his looking at the relationships between colours will take place on the palette. As a starting point, he tries to find extremes of brightest green and reddest red, which he will then refine. He is interested in tonal contrasts that make colours sing. He uses a palette knife to mix the colours but won't use it to paint as he thinks it becomes too mannered.

LUIS'S TOOLKIT

Luis has a chromatic palette rather than an earth palette, which means that his colours are simple, pure colours rather than mixed.

SURFACE 20" x 30" canvas

PAINTS Oils

BRUSHES Short, flat acrylic brushes; he uses four, one slightly smaller for the face but the others medium-sized (he likes his brushes to be as big as possible)

COLOURS Titanium White, Veridian, Ultramarine, Alizarin Crimson, Cadmium Red, Cadmium yellow, Lemon Yellow

SIZE 51 x 76cm

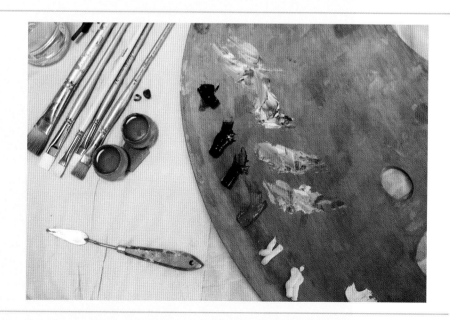

2

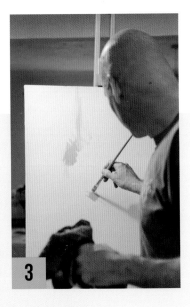

3

CHARCOAL SKETCH

A quick sketch helps him to get his eye in and get some idea in his mind of what he wants to achieve; he finds that things can go wrong if he just dives into the painting. Charcoal is good because he can quickly fill in areas and blend and get just about every tone he wants in there.

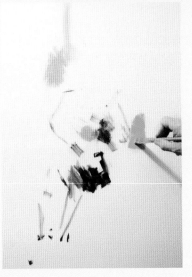

PUTTING DOWN MARKERS

Moving to the canvas, Luis begins painting by putting down markers to get the composition in, starting with a large mark near the top. He holds his brush at arm's length from the canvas so that he's not having to move and can take measurements: at the tip of his mum's foot he adds a line approximating the colour then checks the angle with the length of his brush and gets to the top of his mum's hand, where he adds another line. You could drive yourself mad trying to get all the relationships right, he says, so it's a case of constantly refining.

4

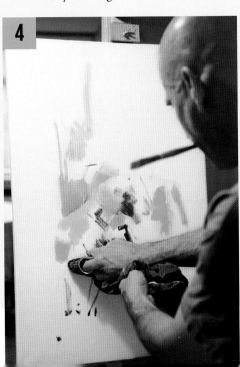

CORRECTING ERRORS

Once he has located his mum within the portrait, he can paint with more confidence. It's too early to put in anything descriptive at this stage. The worst thing is to fall in love with some of your painting only to have to scrub it out because it's two centimetres away from where it should be, he explains. (This is a particular challenge today because his mum moves quite a lot.) When he makes a mistake, he wipes it off with turps using an old rag and then paints over it.

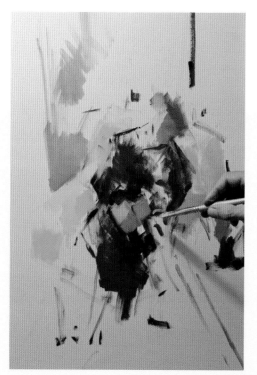

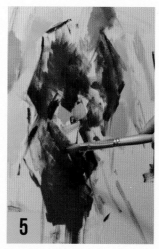

5

DEFINING EDGES

One of his major concerns is the colour balance: he couldn't paint his mum's face in and then add the black outfit as it might turn out that her face is too pale and ghostly, so he needs to get the dark colours in first. His style combines dynamic lines to place her and flat patches of colour. He puts colours in roughly where they are and then can contract or expand them. He was taught to see painting as colours jostling for a position on a canvas: you define an edge of a colour by another colour; you're not just filling things in. In this way, the drawing and the painting happen at the same time.

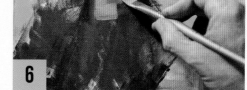

6

PAINTING THE HEAD

Shortly before midday, he starts painting his mother's head, taking advantage of the fact that she is sleeping and so has stopped moving. (Normally, he would have preferred to leave this until later.) The colours intersecting around it are forming it. He begins to paint the shadows on her face. At this stage, he's looking at the painting a lot in the mirror, checking to see what's working and what isn't.

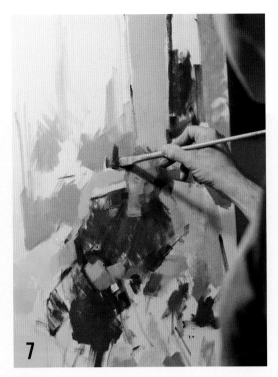

LOCKING IN THE COLOURS

Luis needs to lock in the colours around his mother to help her become clearer. There are cool and warm greens on the blanket and he tackles those: where the green is mustardy, he adds some cadmium yellow; where it's colder, he goes for the lemon.

FOCUSING ON THE FACE

Having spent a couple of hours working mostly on the face, Luis is happier with the portrait. He thinks he's finding her – up until now it didn't look anything like her. It's a question of tone as well as solidity, modelling and seeing how the shapes interlock. Which colours make her? He doesn't want to just paint her in browny orange, or dark and light. The aim is to get the eye of the viewer to the head.

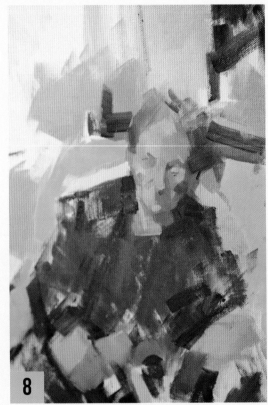

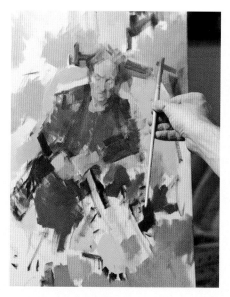

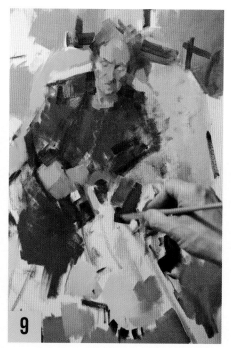

ESTABLISHING ANGLES

Luis steps back to see what the painting is telling him it needs and decides that it still lacks space and solidity. He needs to re-establish that there is a box, angles between the right sofa arm and the other arm. The paint is starting to get thicker, which he is taking as a sign of confidence. He is trying to get the bottom of the chair so his mum looks set back in it, but the dark greys of her outfit make this a challenge. The stick will hopefully keep her grounded in the space.

DEFINING DETAILS

There are all sorts of things the portrait still needs – it's a case of prioritising them. He likes the positioning of his mother's hands on the cane but decides not to do them in great detail. He moves onto the tassels of the blanket on the sofa and adds details to define the forms a bit more.

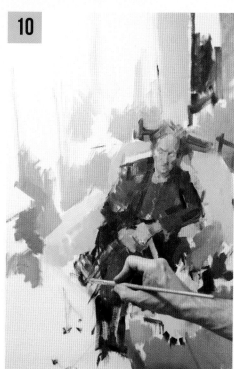

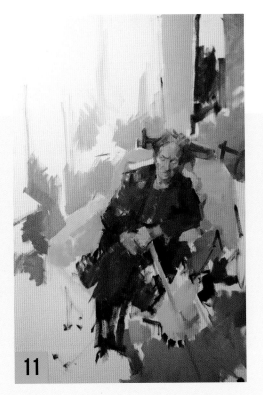

11

DECIDING WHAT TO OMIT

By completing and filling the whole canvas with the wall colour, Luis might improve the portrait, but in doing so, he might also change its nature. He wants to represent some of the colours only abstractly, so puts some patches where the dogs are. He also wants to add some activity, but he's torn: he doesn't want the surroundings to distract from his mum's face and yet neither does he want them to be too muted, because in reality, she isn't out there forcing you to look at her. He wants his mother to be 'quiet' amongst it all, as though you almost wouldn't notice she's there, asleep in her chair. It works.

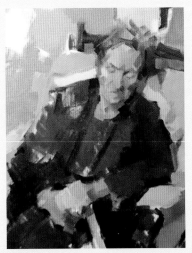

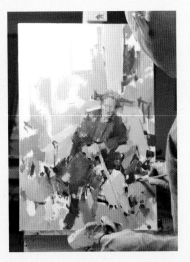

'YOU DEFINE AN EDGE OF A COLOUR BY ANOTHER COLOUR, SO YOU'RE NOT JUST FILLING THINGS IN. THIS WAY, THE DRAWING AND THE PAINTING HAPPEN AT THE SAME TIME.'

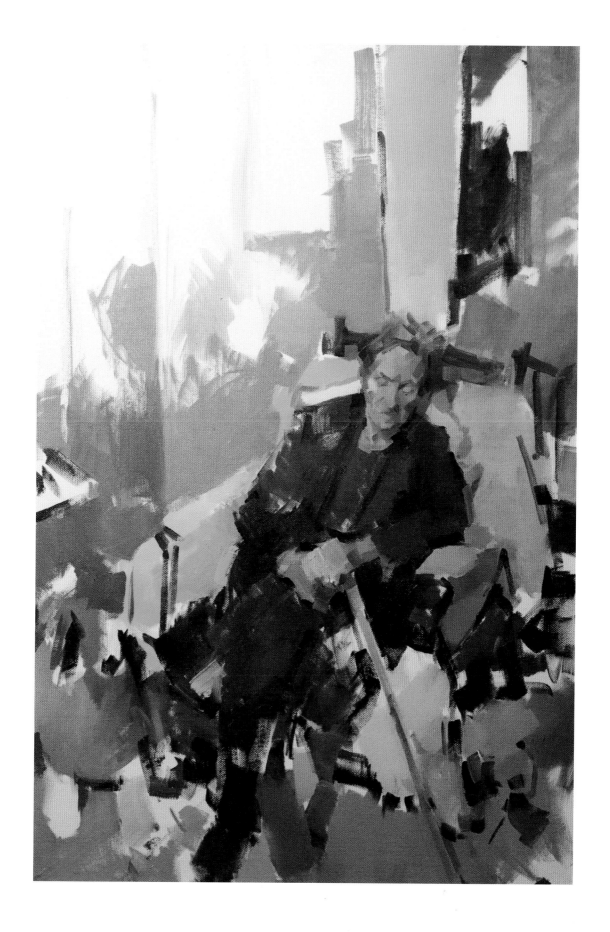

EWAN McCLURE

PAINTS IN OIL

Ewan studied at Gray's School of Art in Aberdeen where, with the exception of the weekly life class, he felt the training lacked rigour. Creative experimentation was encouraged, but there were no live painting demonstrations, so it was to art manuals like Harold Speed's *Oil Painting Techniques and Materials* that Ewan turned for instruction. He agrees that there are now more academic-style ateliers teaching the sort of skills he was looking for, but feels that their rarefied perfectionism might breed a uniformity of approach. When Ewan won his heat in Scotland, with a small but powerful portrait of Michael Kerr, it was clear to the judges that here was someone who had evolved his own dynamic and contemporary take on classical painting.

A Good Portrait

'Whatever else it achieves, a good portrait is visually satisfying. Something about the way the paint is handled and applied just forces you to keep looking', he says. He believes it is his job as a portrait painter to capture honestly what he is seeing rather than impose any assumptions about who the person is. Many a laboured painting has resulted from a self-conscious attempt to spell out a subject's personality, encrypting ideas about the sitter into the image rather than trusting the subtleties of outward appearance to deliver the content. Tracking the light in paint is the way to harness the physical and emotional presence. 'A good portrait exists in real time with the viewer rather than looking frozen and momentary. The visible brushwork preserves the passage of time and the gradual process of seeing and understanding.'

Influences

Ewan admires a lot of nineteenth-century painters for their interest in natural daylight and colour and for their objective viewpoint, which is less about self-expression and more about fidelity to the subject. Among these, he singles out Bastien Lepage, for his humane, rustic realism, and Sargent for his consummate painterly freedom. Neither artist needs gimmicks or distortion to be instantly recognisable through their paintwork. Lepage's coarse textures interplay with more delicately modelled passages, while Sargent favours a fluid and gestural touch, wet-in-wet. He makes it look effortlessly natural, but such an impression is hard-won, with a typical portrait requiring multiple sittings, reworkings and ruthlessly high standards.

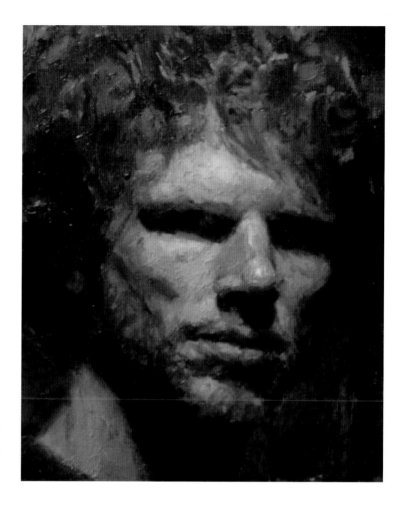

SELF-PORTRAIT
EWAN
MᶜCLURE

Style and Technique

Ewan works in oils and likes to paint wet-in-wet because of the modelling possibilities you get from blending and softening edges. His best advice to young artists is 'use more paint!' He tends to use Winsor and Newton and sometimes Michael Harding paints, but mixes them with stand oil and chalk to get a viscous consistency and more translucency. He discovered, while researching artists' techniques, that both Velazquez and Rembrandt used a similar chalk/oil mix. When painting portraits, his aim is to be loose with his brushmarks and yet precise with his proportions: the better you are as a draughtsman the easier this is, he maintains. To help him achieve the fluid accuracy he aims for, he often uses optical tools such as mirrors and out-of-focus spectacles.

Today's Portrait

Ewan has decided to paint his friend Dave Cooper, a painter and joiner who sings with him in a Georgian choir. He has never painted him before and admits that choosing a friend rather than a paid model for a demo can be slightly inhibiting, with the raised hopes of a favourable likeness. Nevertheless Ewan

owes Dave a wedding present, and a quick portrait seems like a good idea. The sitting takes place in a freezing-cold studio in Cockenzie House, a stately home and arts centre on the coast. Setting up the pose takes about an hour and a half as they try out different poses, different lighting and different backgrounds. Ewan chooses a black background as it works well with Dave's waistcoat and white shirt. Daylight has been blocked out so the lighting can be more controlled: in its place, Ewan uses a natural daylight lamp to illuminate Dave from above to emphasise the hollows of the face and the bone structure in a Rembrandtesque way. He also sets up a sheet of Perspex made blurry with a coat of hairspray in front of Dave as an aid to see the general shapes, blocks of colour and tones, and prevent himself from getting bogged down in unnecessary detail at an early stage.

Unlike during the competition in Glasgow, when he painted Michael Kerr on a landscape-orientated canvas, which gave the portrait great dynamism and narrative drive, Ewan places Dave in an upright canvas to accommodate his tall and lanky physique, though he makes sure to place his head off centre to avoid an obvious symmetry.

Today's portrait is painted on canvas on board, though he generally prefers using primed plywood. Both are strong surfaces, with which you can be quite rough without risk of damage. His palette consists of Alizarin Crimson, Winsor Red, Winsor Yellow, Viridian, Ultramarine, Raw and Burnt Sienna, Ivory Black and Titanium White. He likes big house-painting brushes for blocking in and a variety of hog-hair brushes. Surprisingly, he also likes to use a fan brush, normally used for softening and blending paint, which some artists regard as beyond the pale: Ewan uses it to push large amounts of paint around the canvas and enjoys the variety of marks it can make. Throughout the day, he plays music or lectures to keep the sitter engaged.

FOLLOW EWAN'S TECHNIQUE

FINDING THE RIGHT COMPOSITION

Including time with the model trying out compositions, setting-up takes an hour and a half. Ewan looks through a viewfinder to get a sense of position. Today's portrait will be quite small because of time constraints. He tends to place the model off-centre, with light emphasising the face. Composition is a considered arrangement of elements and he is looking for tensions of large and small, dark and light in order to create interest. Once he starts painting, Ewan tends to block things out quickly and can tell within half an hour if the portrait is going to work, so he can be quite haphazard about getting the exact composition; rather than doing prolonged preliminary sketches he'll just restart it if it's wrong.

EWAN'S TOOLKIT

'Use more paint!' is Ewan's advice to young artists and he uses plenty, mixing them half-and-half with a mixture of stand oil and powdered chalk to give the paint more physicality.

SURFACE Canvas on board

PAINTS Oils mixed with stand oil and chalk

BRUSHES Huge house-painting brushes for blocking in; smaller, hog-hair ones for more detail and fan brushes for softening edges

COLOURS Alizarin Crimson, Winsor Red, Winsor Yellow, Viridian, Ultramarine, Raw Sienna, Burnt Sienna, Ivory Black, Titanium White

SIZE 52 x 41cm

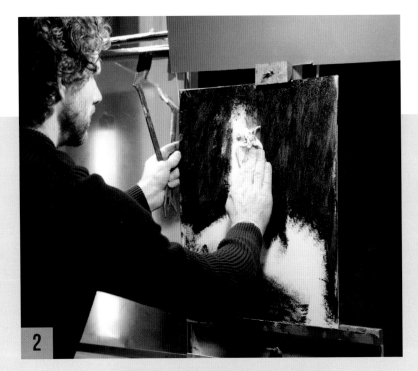

PLACING DARK SHADOWS

Starting out is the most exhilarating point, Ewan claims. He stands throughout the painting process and is very physical, pacing around a lot. He can see if the portrait is coming together more easily by stepping back from it. He begins by scrubbing a thin black tone on the background. He uses brush pressure to keep the paint thin, and avoids using solvents, so that subsequent strokes can be applied immediately without dissolving and trickling. Both the siennas go in next. Ewan hardly measures, he's just placing dark shadows at this point, but the colours he is using are indicative of the real colours present.

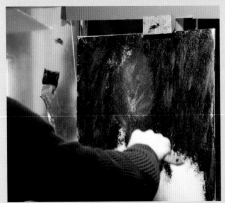

LAYING ON BROAD COLOURS

He puts broad colours roughly on target, giving himself a simple tiled surface to work with. This would be the time to try a radical change if the basic arrangement looks unpromising, before any detail. Painting what he sees rather than what he knows means leaving certain contours undefined, like where the shoulder and backdrop are merged in shadow. He considers the foreground and background as interrelated and being of-a-piece.

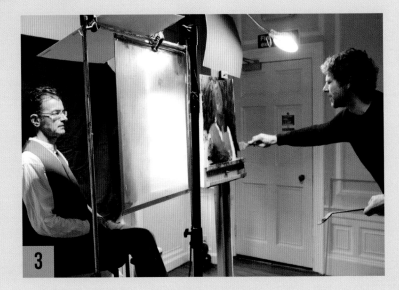

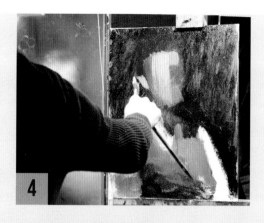

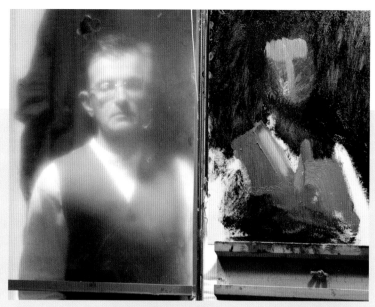

PAINTING WET-INTO-WET

Ewan prefers to manipulate the paint rather than letting layers dry. The stickiness of the stand oil in the paint allows strokes to be layered one over another without the surface getting too slippery.

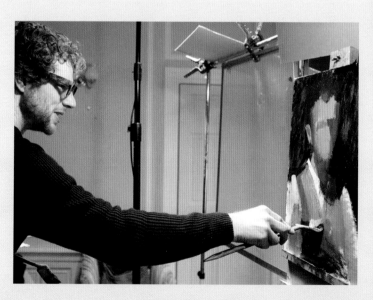

DISCERNING LIGHT AND SHADOW

A sheet of hairspray-coated Perspex blurs the view that Ewan has of his subject. But to simplify things further, Ewan occasionally dons some red glasses. Seeing things all one colour increases his ability to discern the tonal pattern that defines the solid structure. Ewan says that sharp vision can actually be an impediment to loose painting. The original idea of painting with fuzzy specs came to him while reading *The World Through Blunted Sight* by optician and art historian, Patrick Trevor Roper. It's about artists including Titian and Degas, who painted some of their best work in their later years as their vision declined. Seeing with softened focus helps give a unified, painterly breadth to perception, freeing the flow of the brush.

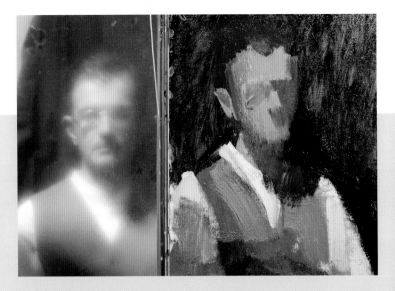

STILL THINKING BIG

At this point, the temptation is to reach for the small brushes and carve up the forms. But Ewan resists the urge to change gear until he's certain the tonal foundation of the portrait is in place. Looking at the subject he tries to imagine the surfaces not as skin, hair and fabric but as slabs of paint in contrasting shades. Finer detail can wait.

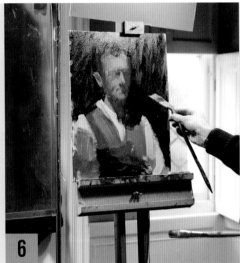

6

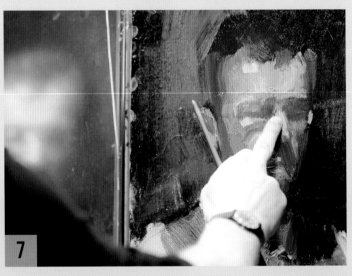

7

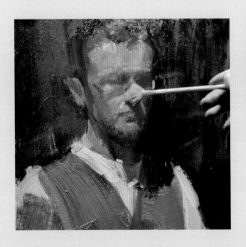

GETTING THE NOSE RIGHT

Narrowing in on forms, Ewan is concerned about getting the position of the nose right: it is really important as an anchor point to which everything else relates as it's the most central landmark of the face. Ideally it would be right first time, but painting is more often a process of making speculative marks, playing 'spot the difference' from a few paces back, then repeating. Figuring out the hierarchy from light to dark gives forms their volume.

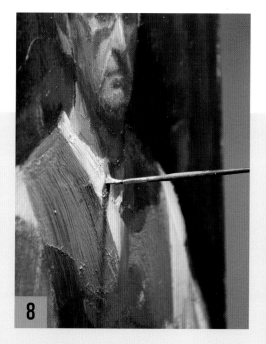

8

VISIBLE BRUSHSTROKES

So far, Ewan likes the chunkiness of the
brushstrokes in the outfit that lead up
to the face. He wants to give the paint
surface interest, rather than taming it to
an even, photographic finish. The stiffness
of the paint mixed with the chalk and oil
means that it is thick enough that he can
put it on and it will stay exactly in place,
retaining the brush texture.

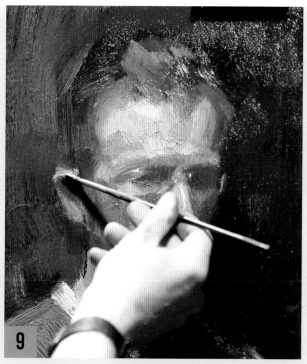

9

GOING FOR DETAIL

Although he can see ever more detail in the subject,
Ewan is trying to be sparing. He wants to keep the broad
brushstroke look, so will add just a few well-chosen
highlights which can sometimes be the difference
between a finished and an unfinished painting.

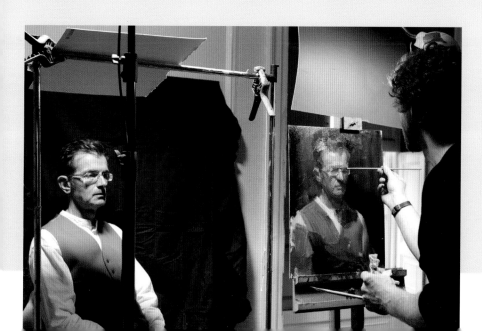

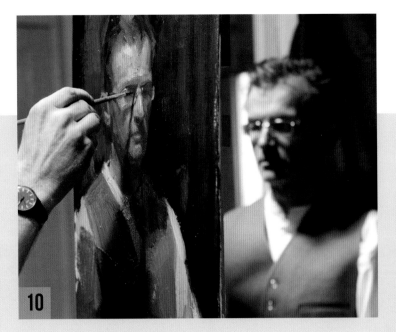

10

REMOVING THE PERSPEX

Ewan makes the decision to take the Perspex off to see whether there are further details he needs to add. He wants to see the exact location of the irises and couldn't do so through all the fuzziness. These are features that can prove a challenge because they can make or break a painting. Even at this stage, the brush is fairly substantial – you can make small marks with a big brush as long as you control it properly, he says.

FINAL TOUCHES

Dave looks too grumpy: he has a frown in the painting that doesn't quite ring true and Ewan needs to sort that out. He makes some final tweaks with a fine brush. Finishing a portrait is about being patient and considered, he believes. It's not copying everything you see, it's selecting what's important: you have to keep asking yourself if, at this stage, an addition or refinement would further strengthen the overall statement.

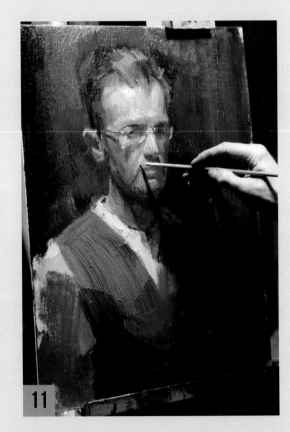

11

'WHATEVER ELSE IT ACHIEVES, A GOOD PORTRAIT IS VISUALLY SATISFYING. SOMETHING ABOUT THE WAY THE PAINT IS HANDLED AND APPLIED JUST FORCES YOU TO KEEP LOOKING.'

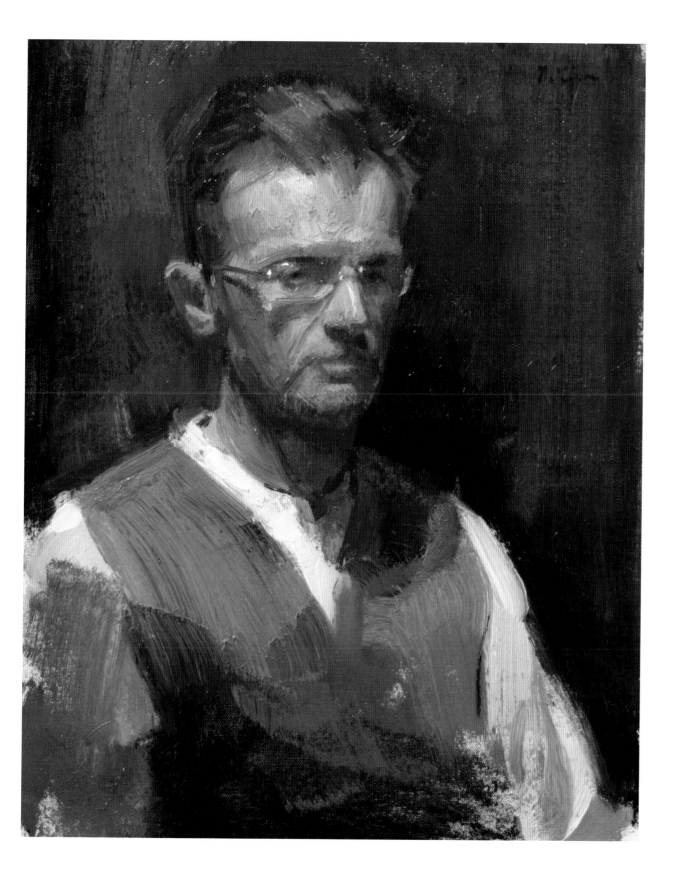

JAMES GREEN

PRINTS USING LINO

James studied Fine Art at Sheffield Hallam University, where he specialised in photography, in the early '90s. However, it took a while working on his own afterwards, and the fortuitous discovery of printmaking, for him to develop his own visual language in a medium with which he felt a great connection. He usually makes prints of animals and landscapes, urban as well as rural, but his self-portrait, which grabbed the attention of the judges with its inventive graphic language and compact clarity, was a first for him. In his heat of the Sky Art's competition, he made a wonderful two-colour linocut of Simon Weston, the Falklands' War Veteran. He co-organises the Sheffield Print Fair and is also a musician.

A Good Portrait

When James discusses portraiture, it is very much from a graphic artist's point of view in the way the medium's limitations and the actual processes dictate the outcome. A good likeness is a priority, of course, as is a strong composition; but when he talks about composition, it is in the context of the planning of a print, something that can take two weeks if it is complicated. If it is a commission, he would want to know what the picture is for, what the person wants to represent. With a linocut, you are limited to a mark or nothing; there is no room for subtleties, and once you've made a decision you can't go back on it. You have to take leaps into the unknown, which is why you have to plan so far ahead. Because of the physical qualities of lino, you can't cut in too much detail, so creating foreshortening is very difficult. However, he does like his portraits to be face on, not only from an aesthetic point of view but also with an eye to creating a series of heads that would work well together. He also adds that you can't really flatter in this medium: it is harsh, black and white.

Influences

His interest in linocut was sparked initially by German Expressionists who produced those slightly ugly, graphic prints you see. Egon Schiele is another favourite because of his spare linear style, as are Max Beckman and Stanley Spencer. Linocuts fit well into James's aesthetic preferences as they are a nice way of making bold images that stick in your head. He doesn't like anything aesthetically too 'fluffy'.

SELF-PORTRAIT
JAMES GREEN

Style and Technique

James prefers black for portraits as it is the most straightforward and least distracting colour, but he does occasionally add another, although he doesn't work in more than two, on the whole. Colour-wise, things that might work in your head or in photography don't necessarily work when printing because the real surface of the ink looks different. His colour choices feel instinctive but are based on a bank of colours in his head. With his style of hatching, he likes to follow the contours of the face he is describing and experience has taught him how to create the right 'grey'. 'You have to use a lot of artistic licence with lino to create texture. You have to use your imagination to create hair, for example. You just have to be brave!'

Today's Portrait

James will be making a lino print of his seven-year-old son, Henry. Henry is at school but his presence will not be needed because working from life isn't an option with linocuts. James has taken a photo of him against a plain background, which he will transfer to the lino. He works at the kitchen table with natural light from the window, which is not only better for his eyes but also makes it easier for him to judge the colours when printing.

Linocut was invented in Germany and James thinks the best materials still come from there: he gets everything he needs from the same German shop. He thinks portrait prints work best in A5 or A6 format, not only aesthetically but also from a practical point of view: if you hand print, as he does, using the back of a spoon rather than a press, printing becomes impractical at larger sizes. James uses professional U- and V-shaped chisels between 2mm and 7mm width to cut lino; he sharpens all his tools each time he does a new picture. He uses fade-resistant inks (mixing the colours himself if he's not just using black). Standard 80gsm white paper suffices for test printing, but once James is happy with the result, he prints on acid-free 220gsm cartridge paper, which doesn't discolour over time.

In his early linocuts, James used to use a cheap set of cutting tools. These were great to learn with, but limited his cutting techniques a little. With experience, he has started to work with finer tools, which, he says, suit his way of working better.

JAMES'S TOOLKIT

In his first linocuts, James used big tools, which made the prints look very primitive. With experience, he has started to work with finer tools, which, he says, suit his way of working better.

SURFACE A6 size lino (made from compressed cork and linseed oil with hessian on the back) and A4 size acid-free 220 gsm cartridge paper

INK Fade-resistant black ink

CUTTING TOOLS U- and V-shaped linocut tools, between 2mm and 7mm width

OTHER MATERIALS AND TOOLS Tracing paper, carbon paper, perspex sheet, small rubber roller, metal spoon

SIZE 15 x 21 cm

FOLLOW JAMES'S TECHNIQUE

PRINTING THE PHOTOGRAPH

Before printing the image he has taken of his son, James flips it so that it is a mirror image, otherwise the portrait will be the wrong way round when printed from the linocut. He prints it in both colour and black and white: colour to define the objects more clearly and black and white to get the tonal range.

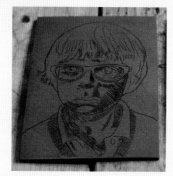

TRANSFERRING THE IMAGE TO LINO

James traces the image using tracing paper, then places this over the lino, with carbon paper in between, and draws over the lines to transfer the image of the face onto the lino surface. He needs to decide, at this tracing stage, which bits of the final portrait will be light, which will be left black and which will be hatched.

DELINEATING THE FACE

The plan is to go for basic shapes first and then cut around them. He starts with fine lines delineating the shape of the face and the glasses with a V-shaped tool. He needs to be delicate with these fine lines: if he makes a mistake, he may be able to work with it – sometimes it can be positive – but it may mean he needs to start again. So he plans very carefully what he is going to do and aims to be accurate with these details before he moves onto the next stage.

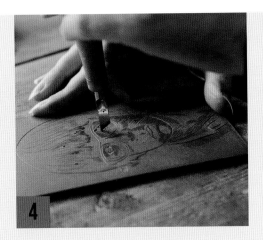

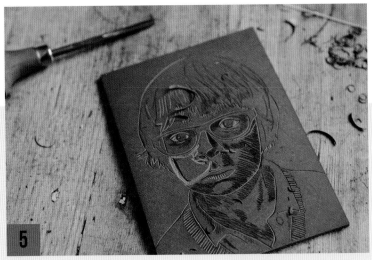

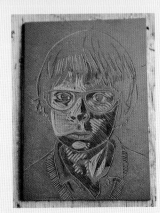

MARKING THE EYE AND NOSE

He uses a little circular tool to correct the mark in the centre of the eye. The nose is hard to do because, as his portrait is face on, it is foreshortened, and so hard to make 3D. It would be easier, obviously, if the portrait was a profile.

CUTTING OUT THE BIGGER SHAPES

Next, he moves on to cutting out the big shapes using wider tools. Lines are cut out in a parallel manner. He has to be careful not to cut out too much by getting carried away. To be safe, he leaves more in and will then do a test print to see if he needs to cut out more.

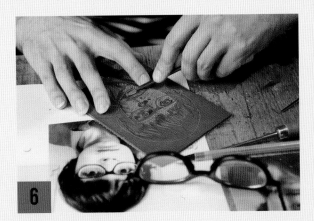

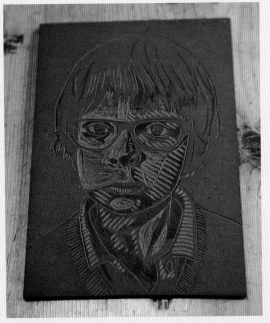

SHADOW HATCHING

James does some more shadow hatching. Some areas need to be completely white and he might work on the shirt a bit more. He draws lines on the lino as a guide. It's exciting at this point because he doesn't know if it's going to work – either aesthetically or in terms of a likeness.

7

DOING A TEST PRINT

For the test print, James uses standard white 80gsm
A5 paper placed on top of the inked lino. One of
the hardest parts of linocut printing is inking up the
plate. If you use too much ink you can flood the lino:
the ink fills the little holes you've cut and overflows so
parts of the print go missing and the result is spoilt.
But if you use too little ink, the result is can look pale
and patchy. To get it 'just right', James builds it up
with thin layers of ink, rolling the ink onto a sheet of
perspex then onto the lino. The first print is always a
little patchy because the lino needs to absorb the first
layer of ink; the second layer will have a better surface
to print.

CLEANING UP

Before he makes a test print, James
needs to make sure he has cleaned
up the printing surface: curls of lino
that he has chiselled out of the image
are all over the place and if they are
not cleared up they will spoil the
printed image.

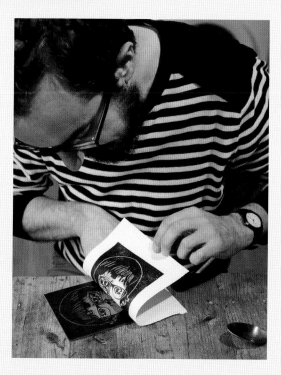

8

TAKING THE PRINT

He drops the paper onto the lino rather than
the other way round. He prefers to hand print,
transferring the print by pressing down on the
paper with a spoon, taking time to make sure
the ink is evenly distributed. This method works
much better for him than using a printing press,
he has found. He does one half, then lifts the
paper, checking that the printing is successful
before doing the other half.

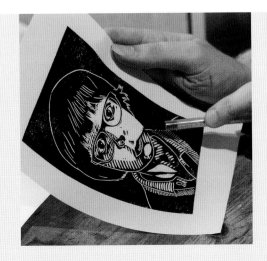

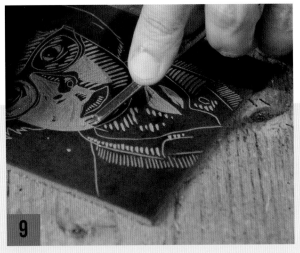

9

MAKING ADJUSTMENTS

Having looked at the test print, James decides that he needs to chip into the line around the cheek to bring the shadows on the chin down so that it doesn't look too soft. He also decides to do a bit on the hair to give it a bit more shine. Having made these adjustments, he is happy.

THE FINAL PRINT

He decides to go for the final print on good-quality, acid-free A4 cartridge paper. This time he needs to be much more careful when applying pressure with the spoon, as the paper is much more likely to slip. Also, as the paper is thicker he can't see the image coming through the back of the it as he applies the pressure, so he points a desk-light at the paper to help him see where he needs to press next. He is happy with the result, which he leaves to dry naturally for two to three hours.

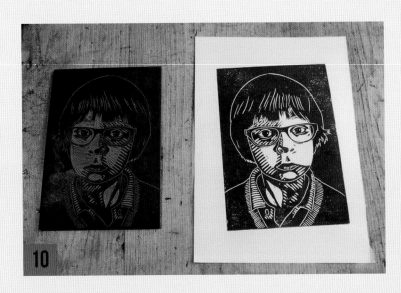

10

'YOU HAVE TO USE A LOT OF ARTISTIC LICENCE WITH LINO TO CREATE TEXTURE.'

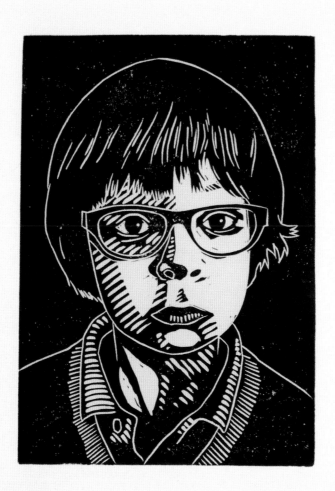

LAURA QUINN

PAINTS IN ALKYD

Laura Quinn, a Maths graduate who also studied Scientific and Natural History Illustration to degree level, was working as a part-time accounts assistant when she entered *Sky Arts Portrait Artist of the Year* 2014. Although she usually paints animals in her spare time, her evocative self-portrait entry caught the judges' eyes with its sensitive rendering, beautiful subdued palette and great emotional depth. Although she had to adapt her style quite radically to the constraints of the competition, it was this emotional acuity that convinced the judges to put her through to the semi-finals as an unprecedented second winner of a heat.

A Good Portrait

Laura believes that a good portrait relies not only on a strong likeness but also on something engaging that draws you in, a hidden depth. She doesn't have a preference for a certain type of sitter, and unlike many artists, she doesn't mind painting young people or children. Whether Ashley Jensen's youthful face in the heats or Sir Ian McKellen's interesting ragged face in the final, she likes painting a broad range of people and is equally happy to tackle the luminosity of a smooth complexion as to get into the wrinkles. Although her portraits in the competition were praised for their emotional depth, she is clear that this is not what she consciously looks for; she's more concerned about getting the features and proportions right and portraying exactly what she sees.

Influences

As well as painting portraits, Laura has spent a lot of time depicting animals – she made etchings of wildlife – and has painted pet portraits. She particularly likes the work of New Zealand wildlife artist Ray Harris Ching, especially his use of light and shade in his quirky but realistic paintings of birds. Bonnard's use of colour has influenced her new, looser style of making portraits.

Style and Technique

Given enough time, Laura tends to make highly finished photorealist images, but we will look at the style she developed to make paintings directly from life in one or two sittings. She likes to work on MDF board because she finds it an easier surface to put detail on than canvas. After painting it with several coats of white gesso to seal it, she applies a coat of dark grey alkyd as a base colour. Laura uses alkyd paint, a mixture of oil paint and very fast-drying alkyd resin, as it enables her to build up the paint in thin layers without having to wait. She also uses Winsor and Newton Liquin, another fast-drying medium, if she needs to improve

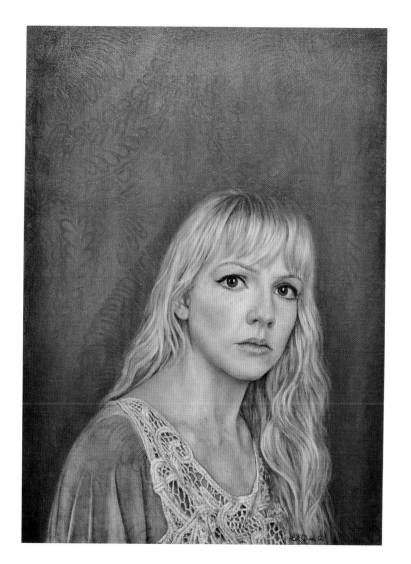

SELF-PORTRAIT
LAURA
QUINN

the fluidity of the paint. To apply the paint, she prefers the softness of synthetic brushes, usually three sizes, from medium to small, with round tips. She paints in small delicate strokes and rubs out her mistakes with her fingers. Should she need support for very detailed work, she resorts to using a mahlstick. Although she has done a lot of life drawing in the past and is a good draughtswoman, she doesn't like to waste time, so uses a grid to transfer the proportions as expediently as possible from the gridded photo she has taken on her iPad onto the board. 'I'd rather have the accuracy down and then I can put on the layers of paint. The paint is where you build up the proper likeness; it's what I enjoy.' Once the drawing is in place, though, she likes to work from life to capture the correct skin tones. The choice of grey as the ground not only works as a perfect mid-tone, enabling her to paint both lighter and darker, it also shows through and between the coloured paint layers and works well as a shadow. It is a strong ingredient in the way Laura's paintings look and feel.

Today's Portrait

Laura has chosen her mother Kath as a model. She thought it would be interesting to see her own features reflected in another person, but chose her mother over her father because she would be able to include a brighter outfit – she had enjoyed painting Ashley's Jensen's flowery dress in the heats. Interestingly, she has never painted her mother before. The painting session takes place in her tiny studio in her retro house that she is renovating. She has a small daylight lamp clipped onto her easel and a larger daylight lamp on her mother so the lighting is steady as the day progresses. Laura likes her sitters posed front on as it is better for getting an accurate likeness. She sits throughout the process, mainly close up to the easel with the occasional lean back to check the progress from afar, although she does use a mirror frequently to get a fresh perspective on how the portrait is developing and whether the likeness is still there.

After choosing a photo, she transfers the basic outlines from the iPad onto the grey gridded board with a white pastel pencil, starting with the right eye. The iPad is a constant companion throughout the process: she will work off it for some of the portrait, zooming in for details and out again for composition. It allows her to work in fine detail without breaks, which suits her style. Her palette is a reflection of her finely tuned working process. Down the left side, she has tiny blobs of earth tones; in the corner, a large quantity of white; and across the top, small blobs of more vibrant hues such as Cadmium Red and Cadmium Yellow.

FOLLOW LAURA'S TECHNIQUE

PREPARING THE PHOTOGRAPH

Laura takes four photographs of her mum on her iPad and then chooses the best expression. She will work off the iPad for a lot of the day, zooming in and out. Despite being skilled at life drawing, Laura uses a gridding programme on the iPad. It's easier to get the likeness quicker using a grid, so it makes sense; the gridding cuts down on time and enables her to get onto what she enjoys, which is the painting.

LAURA'S TOOLKIT

Laura uses alkyd paints: they look like oil and have some viscosity but they dry quicker and so work well for her as she likes to build up paint in thin layers.

SURFACE Primed 16" x 20" MDF board

PAINTS Alkyd paints and Sansador, a low-odour solvent

BRUSHES Three sizes of medium to small round-tipped synthetic brushes

COLOURS Titanium White, Lamp Black, Raw Umber, Burnt Umber, Raw Sienna, Dioxazine Purple, Flesh Tint, Permanent Alizarin Crimson, Cadmium Red Medium, Cadmium Yellow Hue, Viridian, French Ultramarine

SIZE 41 x 51cm

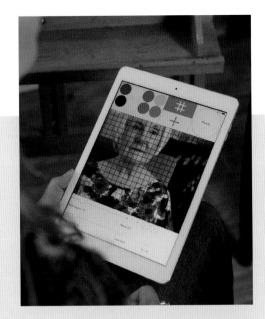

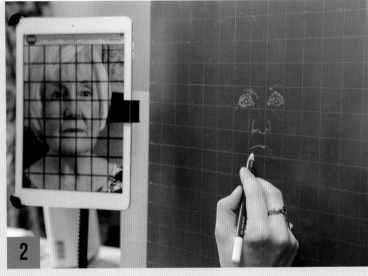

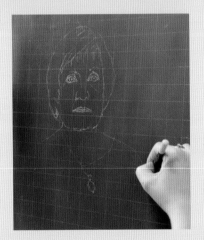

PLOTTING THE OUTLINE

The board has already been primed with white gesso and then covered with a mid-tone grey, so Laura simply has to draw the grid onto it and she's ready to begin. The first stage is to plot the basic shapes. When working on a white background, she would normally use a graphite pencil for this, but as her 'quick technique' involves using a dark grey board, she finds a white pastel pencil most useful. She begins by drawing the right eye. This process is simply about getting the outline and shapes in; she's not looking to add highlights, nor too much detail, just enough to show where everything is.

FIXING THE DRAWING

Once she's finished the drawing stage, Laura tries to rub out the gridlines but they won't come off cleanly. (The putty rubber is good but can leave streaky marks.) She's not too worried, though, as she will be painting over most of them. The pastel pencil rubs out a lot if you touch it, so she generally uses a fixative spray.

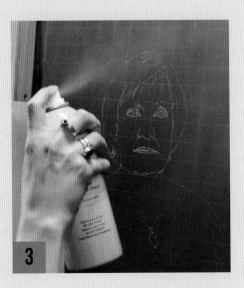

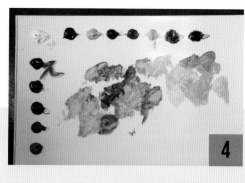

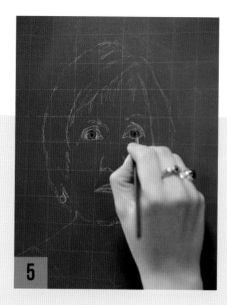

PREPARING THE PALETTE

Without doubt, Laura has the neatest palette of all the artists featured in this book. Although she goes back to a lot of the same colours, she likes to have the whole range on the palette at her disposal and so blobs are neatly arranged, white (the largest amount) in the corner, neutrals down the lefthand side and brighter colours across the top. She mixes in tiny amounts in neat lines across the palette throughout the day.

STARTING TO PAINT

Although she will continue to use the iPad throughout the day, Laura gets her mum back in to pose for the painting phase. She begins painting with a tiny rounded brush, starting on the eyes, which are the focal point. She will come back to the eyes later, but even at this early stage, she paints them in a lot detail before moving outwards.

ADDING COLOUR

The colour and shape of the eyes is followed by pinks on the tips of the nose and nostrils. Laura will try and get a bit of colour everywhere on the face for the first layer. Again beginning centrally and on the chin, she works outwards, adding rough skin-tone colours in the face. She then returns to the eyes and hair for another layer.

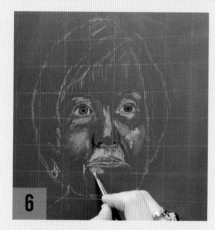

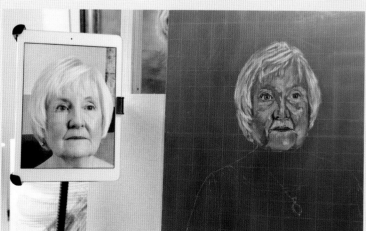

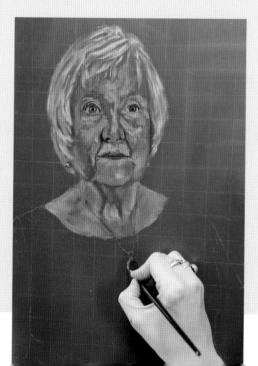

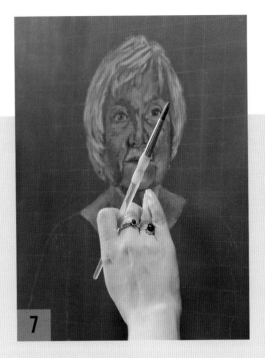

7

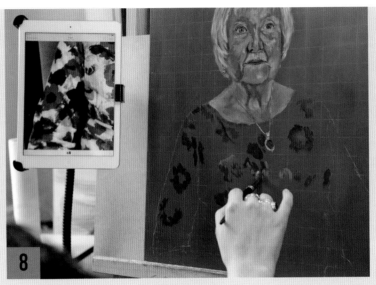

8

MAKING CORRECTIONS

Once she is happy she has got the colours down on the head and hair, Laura moves her attention down to the neck. She paints in small, delicate strokes and if she wants to correct something she's done, she simply uses her fingers to rub it out.

PAINTING THE DRESS

During the heats of the competition, Laura had enjoyed painting Ashley Jensen's patterned dress and wanted to recreate that feeling in this portrait. She also prefers working in bright colours in the quicker style and especially likes the way they work against the grey. She doesn't try to make the pattern on the dress realistic – what she's wanting is simply a bright and colourful contrast to the grey background – so she just dots on the colours – pinks, black, white then greens.

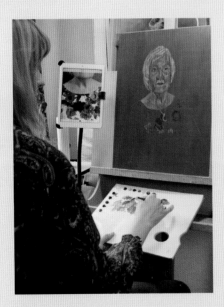

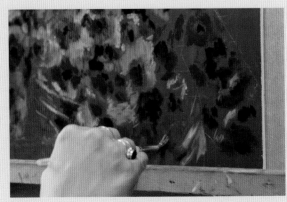

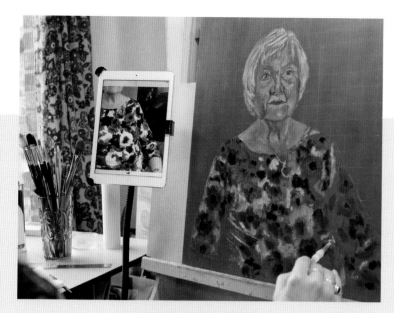

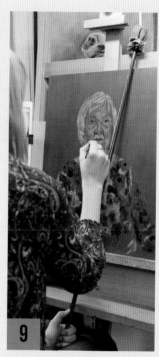

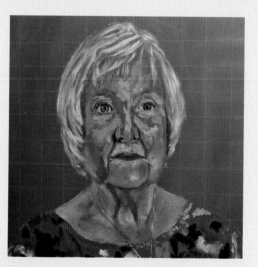

9

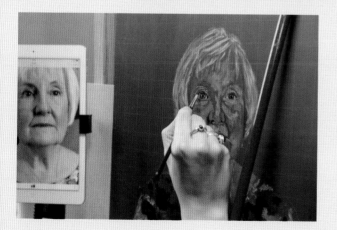

RETURNING TO DETAILS

Having put down the colours in the face, hair, neck and then dress, Laura returns to the eyes. This is where the iPad comes in handy and she zooms in so she can see the detail. To keep her hand steady for fine brushwork like this, she makes use of a mahlstick to support the hand holding the paintbrush.

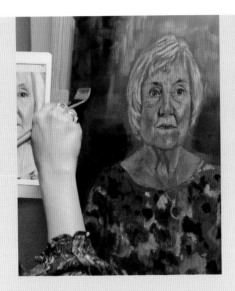

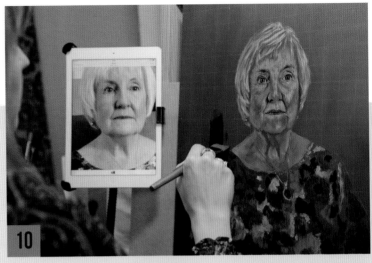

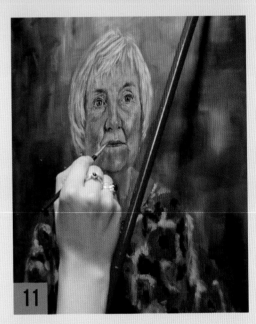

APPLYING A BACKGROUND

She decides to go for a dark green background because there is green in her mum's top as well as in her eyes and so the colours will tie in. There will still be some grey showing through. She starts by applying a dark layer and then puts on some lighter green to mix it up and add a tonal value, adding bits here and there, especially in the centre, around the head, where the dark background was creating too much of a contrast.

ADDING THE FINAL TOUCHES

The background completed, the portrait is all but finished. Laura leans back to examine the portrait, comparing its likeness with her mum and the details on which she's zoomed in on the iPad, and then adds a few finishing touches to the lips, eyes, dress and skin tones.

> 'I'D RATHER HAVE THE ACCURACY DOWN AND THEN I CAN PUT ON THE LAYERS OF PAINT. THE PAINT IS WHERE YOU BUILD UP THE PROPER LIKENESS.'

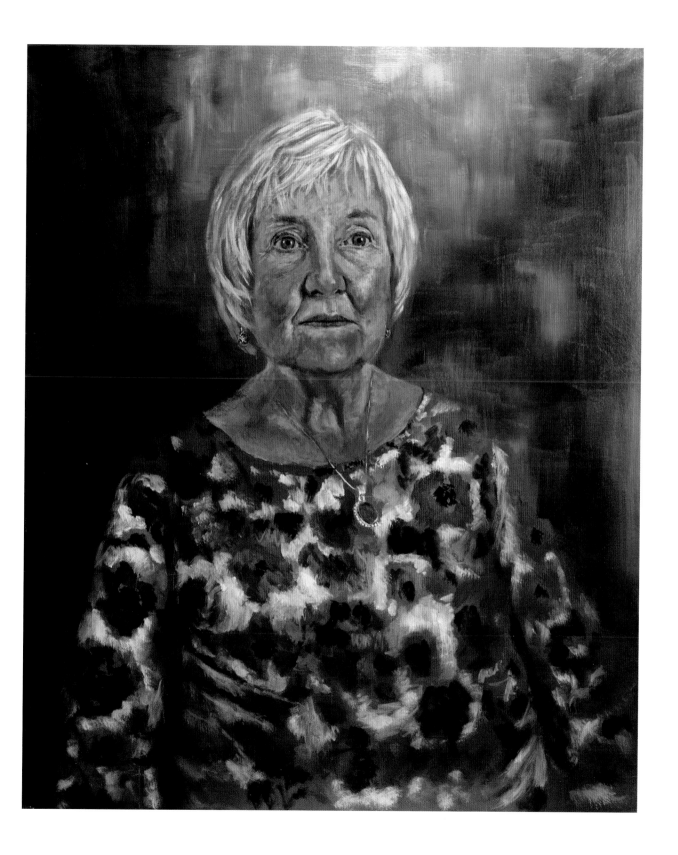

KEMI ONABULE

PAINTS IN OIL

At 18, Kemi was our youngest competitor, and had entered with a refreshingly bold and direct self-portrait that impressed the judges. During the London heat, she made an impact, not only with her very strong, almost expressionistic double portrait of Juliette Stevenson and son, but also with her poise and confidence. She is now half way through a fine arts degree at Wimbledon Art School.

A Good Portrait

'Aesthetically, I want it to look like the person, but not just the face. It's a portrait. It's supposed to encapsulate all these things that make up that person: their expression, their mood, etc. It isn't a photo, you see something moving…' Kemi says that the composition is a vital element in showing varying aspects of the sitter: different dresses exude very different impressions, for example. She suggests that the way the portrait is painted can reflect the mood of the artist as well, be it layered and laboured or motivated and cheerful. 'When it comes to portraits, it's a mixture of channelling the sitter as well as a self-involved process.' She finds a likeness easy to achieve because the process and mark-making is pretty straightforward, so when she has more time, she likes to add a symbolic component to the picture. Although she feels a certain responsibility for the sitter's image, she finds prettiness or flattery quaint; a portrait should be as close to naked as possible, she believes, not merely the facade of the person.

Influences

Kemi occupies an interesting space in this book in that she is young and still studying at a mainstream art college that embraces the contemporary art world and exposes her to all the latest art movements and related visual philosophies. She is trying to balance these influences with the fundamental requirements of portraiture and make something new. In that respect, although she admires Lucien Freud, she also looks at Francis Bacon, Gerhard Richter and Daniel Richter for inspiration. She finds the latter's expressive and unusual painting and his made-up universes with their bright, strange colours beautiful. 'With Freud, I love the way he expresses form, animalistic and cold and not very respectful of the body – he doesn't romanticise. That's what repels you but also draws you in.' She is aware, though, that when one looks at other artists' work too much one tends to end up copying and absorbing ideas and that sometimes it is good to step away.

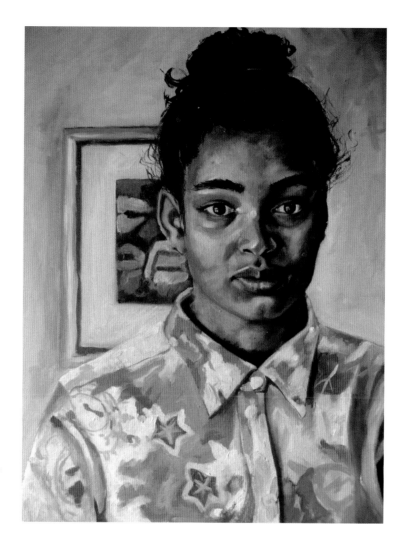

SELF-PORTRAIT
KEMI
ONABULE

Style and Technique

What drew the judges to Kemi's work was her bold, fearless and expressive use of oil paints, and it is interesting to hear her speak about the physical nature of painting portraits and how she finds the combination of that and the technical process a therapeutic experience and very different to the conceptual working methods at art school. She has always drawn, but only began painting a couple of years ago when a tutor saw that the expressive qualities of oil paint might suit her personality. She says she has worked hard at improving, practising and picking up advice from anywhere she could, including YouTube tutorials. She is liberal with her paint and her marks are very gestural, broad and sharp and include a lot of drawing and sculpting of angles.

Kemi likes painting on a variety of surfaces, from canvas to plywood, as long as they have a bit of texture. She starts with a wash of Burnt Umber and Raw Sienna to cover the white of the board before drawing in the main structure and details with the brush. She says she has the composition planned in her head as she has usually done some preliminary work that includes sketches from different angles

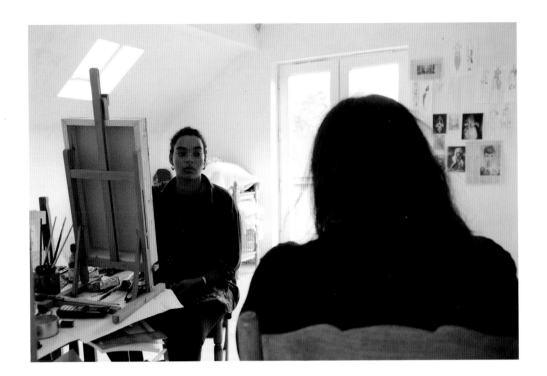

and looking at photographs of the subject. As the portrait progresses and more detail and colours are added, she says it is really just a lack of nerve that sometimes throws her and causes her to feel that this time it might not come off.

Today's Portrait

Kemi has painted her mother before but not for a long time. As the setting, she chooses a room at the top of her house with its big windows and good light; unfortunately, the light fades rather quickly in the afternoon, but it doesn't seem to faze her. Her mother's copious hair isn't the only problem she envisages; because she knows her so well, she's worried she will automatically put in elements that she recognises rather than observing things afresh.

Today, she is painting on a recycled painting on board (18"x12"), which she has sanded down and primed. This recycling of old paintings is common practice at most art colleges. Her staple oil paints are from Winsor and Newton and occasionally from Michael Harding, which are very nice but also very expensive; each term she buys a tube and ekes it out. It is worth it though, because the better paints have a thicker consistency and are more vibrant. She likes to use flat, natural hog hair brushes because they give the most texture when she's working with oil paint, and she uses around ten different ones for a painting. She also finds that they give a drawing quality to the painting.

Although she prefers her sitters to be still, she understands the need for a bit of spontaneity and so doesn't mind some movement. She usually finds chatting distracting, but as her sitter today is her Mum, she doesn't mind.

FOLLOW KEMI'S TECHNIQUE

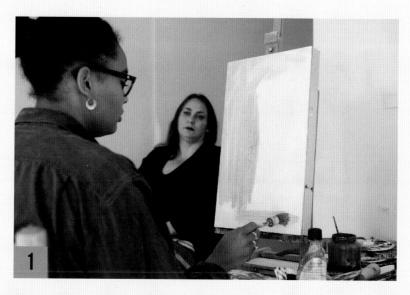

WASHING THE BACKGROUND

Having already sanded down and primed the board, which had previously been used for another painting, Kemi now washes it using a mixture of Burnt Umber and Raw Sienna. She finds it easier not to work from a white board – it helps her to get the flesh tones right.

KEMI'S TOOLKIT

Kemi favours hog hair brushes and uses about ten different ones. She finds they give the most texture when working with oil paint and likes them for the drawing quality they give to the painting.

SURFACE Board

PAINTS Oils

BRUSHES Small, flat hard hog's hair brushes

COLOURS Yellow Ochre, Raw Sienna, Raw Umber, Burnt Umber, Prussian Blue, Scarlett Red, Cadmium Red, Cadmium Yellow, Magenta, Flesh Tint Pink, Portrait Pink, Zinc White

SIZE 50 x 30cm

GETTING IN THE STRUCTURE

Kemi has already planned the composition in her head and now begins painting by outlining the face, getting in the main structures and marking everything that works in the composition purely by eye. She goes into quite a lot of detail, drawing in all the features of the portrait. If she's not happy with the placement, it doesn't matter, as long as it's working anatomically. She can polish things as she goes along, moving features slightly if she feels they're not right.

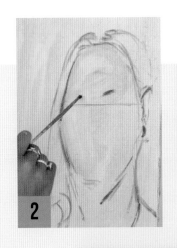

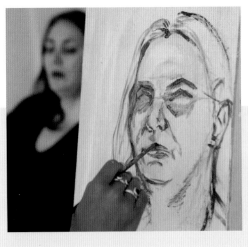

DARK TONES AND SHADOWS

She uses Burn Umber and Raw Sienna to add in dark tones and shadows, getting a bit of a mid-tone by smudging. Then she puts in Venetian Red, which is earthy enough not to get in the way of the next colour.

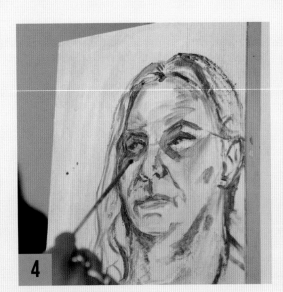

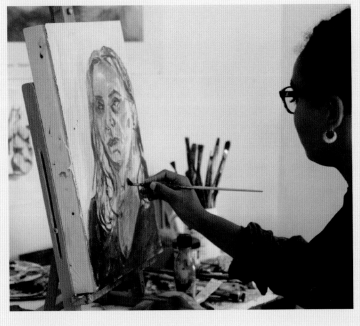

PUTTING IN DETAIL

Some 40 minutes after starting, she is already putting in the irises. The whole shape is now in with shades on top. She likes to put in the detail early as a way to anchor it for the later painting stages. It means there is a recognisable face to work with. Oil doesn't dry so she can rub it out later if she needs to.

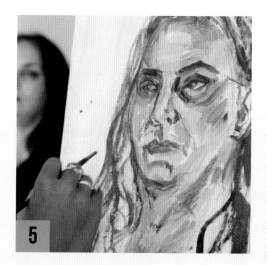

5

INTENSIFYING COLOURS

Kemi starts putting in bright pinks and purples on the cheeks and chin. The skin is not just one colour, she explains, but has many variations and what might look like white is actually greys and greens. She intensifies the colours she sees, exaggerating the purple in the eye socket, for example, in this layer of paint as a marker. She will soften it later. Little flecks of colour make up the final aesthetic.

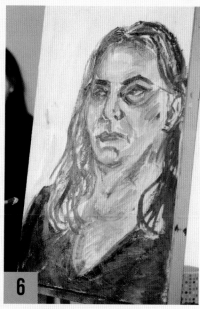

6

MOVING BACK TO SHADOWS

Light blue is added in the corner for variation in tone. Kemi has a preference for this colour 'as it isn't very human'. It's not a flesh tone, so she enjoys the contrast. She likes Turner's paintings because of the way he uses greys and blues so freely, she says, explaining that even though they are landscapes, one can learn and apply those freedoms.

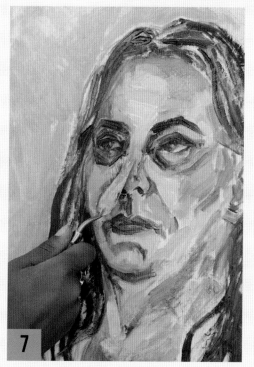

7

CONTRASTING SKIN TONES

She now adds green. Contrasting colours push each other forward, making for a more interesting colourscape. The colours are bleeding, which is one of the problems of dealing with pale skin: there's less margin for error with darker skins. You need lighter contrasts, to be more sparing with what you do so it doesn't get muddy, she explains.

SOLIDIFYING FEATURES

Thick painting creates 'panels' and angles. She needs to solidify features, so adds a sharp line of white on the nose, for example, to bring it forward. The thick texture of the paint makes it more 3D. Kemi doesn't vary her gaze; she isn't constantly looking at her sitter and then at her painting to compare. Rather, she takes an impression of the main things that are important, for example the eyes, rather than looking at every detail of the face.

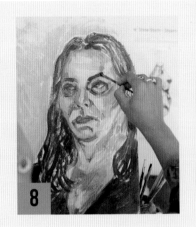

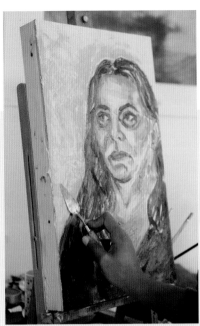

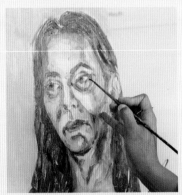

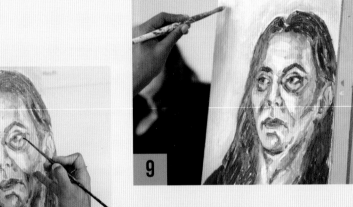

FINISHING TOUCHES

Kemi brightens the background and realises that she needs to address the composition and symmetry of the eyes. She also wants to add some more to the dress and a few other highlights, but then decides that the painting is finished. She says she is learning with each portrait how to pace herself and not to push it; if she tries to do more here, she fears she will ruin it.

> 'WHEN IT COMES TO PORTRAITS, IT'S A MIXTURE OF CHANNELLING THE SITTER AS WELL AS A SELF-INVOLVED PROCESS.'

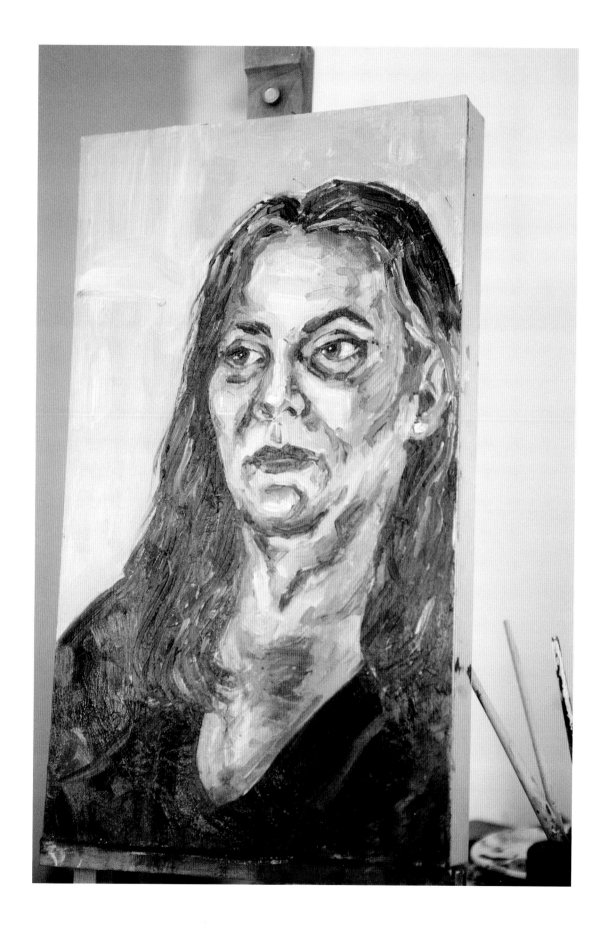

GLOSSARY

A

abstraction/abstract art Refers to any art that is deliberately non-representational.

acetate Thin sheet of transparent flexible material, useful for tracing when working with a grid, for example.

acrylics Acrylic emulsion paints, or polymer colours or synthetic polymer, are water-based paints and the most popular synthetic medium. Because they are quick drying and water-soluble they have become a serious rival of oil paints.

acrylic gesso *See* gesso

acrylic medium gel A thickening medium that can be added to acrylic paint to create texture, increase its transparency and speed up drying time.

alkyd resin An oil-modified polyester that can be mixed into oil paint to speed up drying time.

alla prima A painting technique, mostly used with oils and also known as wet-on-wet or direct painting, where paint is applied directly to the support without underpainting and built up in successive layers, so colours are blended into the previous layer before it has dried.

atelier An artist's workshop. In an atelier school, an artist (or artists) will work with a small number of students to train them.

B

background The area of a painting depicted as furthest away from the viewer. In a portrait, this area is often left plain to direct focus onto the subject.

binder A substance used to hold the pigment particles together to form a cohesive coating and attach it to the support (e.g. linseed oil in oil paints).

blending Mixing of colours either on the palette (most usual in the case of acrylic paints, which are fast drying) or on the support.

blocking Defining/plotting major shapes.

board Often used as a painting surface for oils or acrylics instead of canvas, particularly if thick layers of paint are to be built up. Also used to attach paper to when this is the painting surface.

bristle Used in artists brushes. May be natural – either soft hair or hog bristle – or synthetic.

brushwork The way in which the brush is used as evidenced in a painting. An important aspect of painting that can be used to impart movement, energy and textural detail.

C

canvas A popular painting surface (support) for oils and acrylics. Typically stretched over a wooden frame (a stretcher) and primed with gesso before painting, but pre-stretched and pre-primed canvases are readily available in a wide range of sizes.

carbon paper A sheet of polyester or other plastic film with an ink coating on one side, used to transfer an image onto another surface by drawing or writing on the reverse side.

cartridge paper Thick paper, sometimes with a rough texture, used for drawing and printing.

charcoal Used as a drawing medium either in compressed or 'willow' form or as charcoal pencils. It can also be used in powdered form. Charcoal is soft, easy to blend and good for making loose, rough sketches but needs a fixative.

chinagraph Also known as a grease pencil, wax pencil or china marker, a chinagraph pencil is a wax writing implement that can be used for marking hard, glossy surfaces as well as acetate.

chromatic Relating to, or consisting of colours. (Highly) coloured.

cold-pressed Type of medium-rough watercolour paper, also known as 'NOT', i.e. not hot-pressed.

complementary colours Colours opposite each other on the colour wheel: red – green, blue – orange, yellow – violet.

composition The art or process of arranging elements into a cohesive and pleasing whole.

conté crayon Square-sectioned sticks in black, white and earth tones; bolder than pencils but easier to control than charcoal.

contour line The outline describing the edge of a form.

crayon Any drawing medium in stick form.

cropping The removal of the outer edge or edges of an image to accentuate the subject matter or otherwise improve the composition.

cross-hatching *See* hatching

D

dammar varnish A varnish made from dammar gum mixed with turpentine, commonly used in oil painting both during and after painting.

daylight lamp A source of artificial light, fluorescent or incandescent, whose energy distribution approximates that of natural sunlight.

diffuser A device that spreads light from a light source evenly and reduces harsh shadows.

direct painting *See alla prima*

DSLR A digital single-lens reflex camera enables the photographer to accurately view through the lens the image that will be captured and uses a digital imaging sensor as opposed to photographic film.

dry pastels Drawing medium made from powdered pigment mixed with wax. Pastels are easy to blend but need to be fixed to prevent smudging.

E

easel A freestanding, adjustable structure used to support a painting while it is being worked on. The classic three-legged version with pegs was developed during the Renaissance. Lightweight, portable versions for working outdoors, as well as table-top easels, are also widely used.

encaustic Paint, in liquid or paste form, made from pigment bound with melted beeswax and resin and fixed with heat after application.

expressionism In general usage, implies heightened subjectivity or emotion. More specifically (with a capital 'E') refers to a modernist movement of the early twentieth century, proponents of which used non-naturalistic colour and striking forms to intensify the emotional impact of their paintings. Immediate forerunners include Gauguin, Van Gogh and Edvard Munch.

F

fan brush A brush with a thin layer of bristles spread out in a fan shape, most often used for blending broad areas of paint.

figuration The art of representing a human figure.

fixative (spray) A liquid, similar to varnish, sprayed over a finished piece of artwork (notably one in dry media such as charcoal or dry pastels) to prevent it smudging.

foreground The area of a painting depicted as nearest the viewer. Objects in the foreground appear larger because of their apparent proximity and are painted in greater detail.

foreshortening The diminishing of the dimensions of a figure in order to depict it in a correct spatial relationship.

format The size and shape of a painting. If it is rectangular, the orientation can be vertical (portrait) or horizontal (landscape).

G

gesso A white paint mixture consisting of a binder mixed with chalk or gypsum used to prime canvas or board ready for painting. Acrylic gesso – chalk or gypsum mixed with acrylic emulsion – is frequently used for this.

glaze In oil or acrylic painting, a thin layer of transparent colour used over another layer of paint to increase luminosity.

graffiti (plural of graffito) In its broadest sense, any technique of producing a design by scratching through a surface of paint or other material to reveal an underlying ground. More usually refers to writing or drawings that have been scribbled, scratched or sprayed on a wall or other surface, often in a public place and usually illicitly. Graffiti art became a vogue in the mid-1970s and 1980s, mainly in New York.

graphite Crystallized form of carbon used as a drawing medium, either in stick form or encased in wood as a pencil, where powdered graphite is mixed with a clay binder.

grid In the context of this book, a framework of squares drawn over a printed photograph, or applied to a digital image that is then transferred proportionately to the support to be painted or drawn on. This enables the original image to be accurately copied, one square at a time, so that the image can be accurately reproduced, square by square.

ground The initial coating layer (e.g. gesso) applied to a support to prepare it for further paint layers. Synonymous in this context with primer.

gsm In the metric system, grams per square meter is the measure used to refer to paper 'weight' or grammage (officially expressed as g/m2 but gsm more commonly used). Typical office paper is 80gsm, for example, while the most common weight of watercolour paper is 300gsm.

gummed paper tape Kraft paper with a water-soluble adhesive on one side, sold mostly in 7.5cm (3in) wide roll form, gummed paper tape becomes sticky once moistened and is used to securely attach watercolour paper to a board.

H

hake brush A broad, Asian-style brush with a long flat handle, short square tip and very soft bristles used for applying paint over large areas.

hatching A drawing technique using fine, closely set parallel lines to create tonal variations. In cross-hatching, a series of lines is drawn over the top of the hatching at an angle.

hog hair/bristle Stiff bristle sometimes used in brushes, particularly for oil painting.

hot-pressed Type of smooth watercolour paper. Watercolour paper can also be medium-rough (*see* cold-pressed) or rough.

I

impasto Medium added to oil or acrylic paint to make it thicker. Also the technique of painting with such thick paint, where paint is often applied and modelled with a palette knife rather than a brush.

indirect painting The building up of paint in layers, allowing each to dry before adding the next. It is important to work from 'lean' to 'fat', i.e. from transparent, thinner colours to thicker, more opaque ones. *See also* wet on dry.

intensity The measurable amount of brightness, strength or purity of a colour.

K

Kolinsky sable Generally considered to make the finest (and most expensive) artists' brushes, particularly for watercolour, though lesser grades are also used in oil painting. The hair is obtained from the tail of the Kolinsky, which is actually a species of weasel not a sable.

L

life drawing Drawing the human figure from a living, normally nude, model.

likeness A pictorial representation of something; a portrait. Also the fact of such an image closely resembling the object or person it represents ('a good likeness').

linocut A printmaking technique, similar to woodcut, in which a design is cut into the surface of a sheet of linoleum, which is then inked with a roller and pressed onto paper or fabric.

linseed oil The principal drying oil used in oil paints. It can also be used as a medium to make the paint more transparent, fluid and glossy.

luminosity In the context, the quality of paint or a painting to reflect light, often achieved through glazing in oil painting.

M

mahlstick A wooden stick used to support the hand when painting details. It often has a ball-shaped pad of soft leather at one end to minimize the risk of damage to the painting.

marker A felt-tip pen with a broad tip.

masking fluid A liquid, also known as frisket, used in watercolour painting to block out areas of the painting to keep them free of colour. It can be rubbed off the painting once completely dry.

MDF Medium-density fibreboard is an engineered wood product, usually denser than plywood, made from wood fibres combined with wax and a resin binder. It provides a smooth surface for oil or acrylic painting.

medium In general terms, the material or method used by an artist (e.g. acrylics, oils or watercolour). More specifically, the liquid in which pigment is suspended in paint (e.g. linseed oil in oil paint) or that is added to paint to change its nature, for example by thinning it (e.g. turpentine) or making it thicker (impasto), or more translucent (glazing medium).

mise-en-scene A French term that means 'placing on stage'. In this context, the composition of the scene to be painted, including the placement and pose of the model, background, props, lighting etc.

N

negative space The shapes formed by the empty spaces around and between objects as opposed to by the objects themselves.

NOT *See* cold-pressed

O

oil bar/stick Oil paint in solid form, made by combining the same pigments and drying oil, as are found in oil paint, with wax and then compressing and rolling it into a crayon.

oil pastels Drawing medium made from pigment bound with waxes and oils. Unlike dry pastels they do not need fixing.

opacity The quality of lacking transparency.

overpainting The final layers of paint applied over some type of underpainting when working in layers.

P

painterly In broad terms, concerned with tone and shape rather than line, but generally used to describe a painting or style in which the brushwork and qualities of the paint are clearly visible.

painting knife Similar to palette knife (*see below*) but with a less flexible blade, painting knives come in many different styles, shapes and sizes and can be used in place of a brush for applying paint to the canvas or board.

palette The surface used to mix paint colours before applying them to the painting surface. Different types of paint require different types of palette. (*See also* 'stay-wet' palette and page 15.)

palette knife An artists' tool used for handling the paint on the palette and spreading it on the support. A palette knife has a rounded, very flexible, blunt steel blade set in a wooden handle, often with a slight crank between the handle and the blade.

pastels *See* dry pastels and oil pastels

perspective The art of depicting solid objects in two-dimensional form.

photorealism An art movement that began in the US in the late 1960s, photorealism involves the use of photographs as primary visual reference and aims to replicate them in another medium with the highest degree of representational verisimilitude possible.

pigment The finely powdered colouring material, derived from natural or artificial sources, which is suspended in a medium in paint.

Pointillism An art movement and technique (developed by Georges Seurat in the late nineteenth century) in which colour is applied in patterns of small distinct dots rather than brushstrokes to form an image.

pose The placement, position and attitude assumed by the model for painting.

primer The initial paint layer applied over the support to prevent the absorption of subsequent layers of paint and possibly to modify the colour and/or texture of the surface.

proportion The correct relationship, in terms of size, shape and position, between the different parts in a composition. In particular, in this context, how facial features relate to each other and to the face as a whole.

S

sable *See* Kolinsky sable

saturation Refers to the intensity (or purity or depth) of a colour.

secondary colours Colours obtained by mixing two primary colours together: violet (blue and red), green (blue and yellow) and orange (yellow and red).

shadow hatching *See* hatching

shellac A resin secreted on trees in Thailand and India by the female lac bug. The processed dried flakes are dissolved in ethanol to make liquid shellac, which is used, among other things, in French polish, as a binder in India ink and as a primer, particularly for wood.

siccative medium A substance added to paint to promote fast drying.

sight-size method A method of drawing and painting an object exactly as it appears to the artist. The canvas or board is set up so that the surface appears the same size as the model and the artist then uses a stick and/or other tools to take visual measurements rather than relying on mathematical rules of perspective and proportion.

sketch Rough, rapidly executed freehand drawing to record what the artist sees or as a preliminary stage for a more complete drawing or painting.

solidity In this context, giving the impression of having three-dimensional mass or volume.

squirrel mop A large-format brush with a rounded edge made from (soft) squirrel hair. Useful for creating watercolour washes and for applying glazes over existing drying layers of paint without damaging them, for example.

stand oil Made from linseed oil that has been heated under controlled, oxygen-free conditions, stand oil is non-yellowing and thicker than linseed oil, which improves paint flow, and is an excellent, though slow-drying, glazing medium.

'stay-wet' palette A special palette for acrylic paints that prevents them drying out, it comprises a shallow tray lined with a damp absorbent layer under a non-absorbent layer on which paints are mixed.

stretcher Wooden frame on which canvas is stretched prior to painting.

support The drawing or painting surface, e.g. canvas, board, paper etc.

T

terre-verte Literally 'green earth', terre-verte is an olive-green pigment made from glauconite, a type of clay.

tone (or tonal value) The degree of lightness or darkness of an area. Tone can also have to do with whether a colour is bright or dull, warm or cold.

translucency The quality of being clear or transparent, reflecting light. Certain types of paints (e.g. watercolours) and colours are more translucent than others but all paints can be thinned down (with water or a medium depending on the type of paint) to make a colour more translucent.

turpentine The traditional solvent for oil paint. As turpentine (turps) produces noxious fumes, many artists prefer to use odourless mineral spirits (OMS) instead.

U

underdrawing/underpainting A layer of paint below the top layer. This may be a drawing or painting of the outline of the subject before colours are applied or a priming layer or wash of paint over the whole surface.

V

viewing frame A window created to enable the artist to frame the subject in order to view it more clearly. This can be formed from a square or rectangle cut into a piece of card or by using two L-shaped pieces of card – or simply the index finger and thumb of each hand – placed at right angles to each other, which enables the frame to be made smaller or larger.

W

wash A layer of thin paint applied over the whole surface, or a large area. This is notably a key aspect of watercolour painting (*see page 20*).

watercolour paper High-quality, heavy paper used for watercolours. Watercolour paper is available in a variety of textures (*see also* cold-pressed *and* hot-pressed) and weights. The latter is expressed as grams per square metre (gsm, *see above*) in metric and as pounds (lb) in imperial, the most commonly used being 300gsm (140lb).

wet on dry A method of painting, notably in watercolours, where colours are built up in layers, new colours being added only once previous layers have dried.

wet into wet *See alla prima*

white spirit A solvent, also known as turpentine substitute, commonly used to clean oil brushes and sometimes to thin oil paint. It is cheaper than turpentine but lower-quality grades may leave a residue.

INDEX

SKY ACKNOWLEDGEMENTS

Everyone at Sky Arts would like to thank the team at Storyvault for creating such a wonderful show. Tai Shan Schierenberg for taking the time to share his wisdom in this book and also fellow judges Kate Bryan and Kathleen Soriano, hosts Frank Skinner and Joan Bakewell and, of course, all the wonderful artists and sitters who have taken part in the show so far. It's truly inspiring.
Phil Edgar-Jones, Director of Sky Arts

STORYVAULT ACKNOWLEDGEMENTS

Storyvault Films would like to thank all the brilliantly talented artists who have contributed to the series and especially to those who are featured in this book, for your time effort and the beautiful portraits you have created. We thank our fabulous presenters, Joan Bakewell and Frank Skinner, and to our superb judges Tai Shan Schierenberg, Kathleen Soriano and Kate Bryan.

Our huge gratitude to Philip Edgar Jones, Celia Taylor and Bill Hobbins, Sarah Sedazzari, and the fantastic team at Sky Arts for their magnificent support.

Thank you to Jane O'Shea, Romilly Morgan, Helen Lewis, Nicola Ellis, Charlotte Medlicott, Vincent Smith and Stephen Lang and all the team at Quadrille.

Our thanks to The National Portrait Gallery and all the other wonderful galleries and museums throughout Britain and Ireland who have hosted our productions.

Lastly, huge thanks to our very own *Portrait Artist of the Year* production teams (series one and two), without whom this book would not be possible. But especially to Rocio Cano for making it a reality.
Sam Richards, Storyvault Films

Publishing Director: Sarah Lavelle
Creative Director: Helen Lewis
Editor: Romilly Morgan
Copy Editor: Anne McDowall
Designer: Nicola Ellis
Photographers: Charlotte Medlicott, Jon Woods & the artists
Researcher: Rocio Cano
Production: Vincent Smith, Stephen Lang

First published in 2015 by Quadrille Publishing
www.quadrille.co.uk

Quadrille is an imprint of Hardie Grant. www.hardiegrant.com.au

Introduction text © 2015 Tai Shan Shierenberg

STORYVAULT FILMS

This book accompanies the series *Sky Arts Portrait Artist of the Year* which is a Storyvault Films Production for Sky Arts ©British Sky Broadcasting Limited 2014

Photography © 2015 Charlotte Medlicott
Self-portraits © 2014 Jon Woods

Design and layout © 2015 Quadrille Publishing Limited

Cataloguing in Publication Data: a catalogue record for this book is available from the British Library.

ISBN: 978 184949 652 0

Printed in China